DARK TALES

THE SNOW QUEEN

A GRAPHIC NOVEL

HANS CHRISTIAN ANDERSEN
ILLUSTRATED BY EMILIE MAJARIAN

San Diego, California

Canterbury Classics
An imprint of Printers Row Publishing Group
10350 Barnes Canyon Road, Suite 100, San Diego, CA 92121
www.canterburyclassicsbooks.com

Printers Row Publishing Group is a division of Readerlink Distribution
Services, LLC.
The Canterbury Classics, A Novel Journal, and Word Cloud Classics
names and logos are trademarks of Readerlink Distribution Services, LLC.

All correspondence concerning the content of this book should be
addressed to Canterbury Classics, Editorial Department, at the
above address.

Publisher: Peter Norton
Associate Publisher: Ana Parker
Publishing/Editorial Team: April Farr, Kelly Larsen, Kathryn Chipinka,
Aaron Guzman
Editorial Team: JoAnn Padgett, Melinda Allman
Script and introduction by Sophie Collins

Conceived, Designed and Produced by Quid Publishing,
an imprint of The Quarto Group
The Old Brewery, 6 Blundell Street,
London N7 9BH, United Kingdom
T (0) 20 7700 6700 F (0)20 7700 8066
www.QuartoKnows.com

Library of Congress Cataloging-in-Publication Data available upon request
ISBN: 978-1-68412-102-1
Printed in China
22 21 20 19 18 1 2 3 4 5

CONTENTS

INTRODUCTION

When "The Snow Queen" was first published in 1844, Hans Christian Andersen was still a long way from holding the iconic storyteller status he does today. He was nearly 40 years old, disappointed in love, and yet to achieve even modest commercial success.

More than 170 years later, the picture is very different. Andersen's work is well known all over the world, from simplified versions for the very young to big-screen adaptations—"The Snow Queen" was, after all, the original inspiration for Disney's *Frozen*. Who hasn't read, or had read to them, "The Ugly Duckling" or "The Emperor's New Clothes"? And of all his tales, it's "The Snow Queen," with its ambivalent morality, eerie landscapes, and palpable, bone-numbing cold, that sticks in the memory, however long it is since you first heard it.

Andersen's own snow queen was said to have been the feted Swedish opera singer Jenny Lind, who became his friend but could not return his love. Although the two remained close, the rejection hurt and his imagination responded by shaping a chilly, implacable power, the heartless ruler of an icy kingdom. And as a counterpoint, he created the fiery demon and his workshop of imps, toiling away on schemes to bring ugliness and unhappiness to the world.

The magic mirror, broken into a million evil pieces, kicks off the story's action by turning Kay, a happy, ordinary child, into a chilly little horror who rejects Gerda, his equally happy longtime friend, in favor of a big adventure. At the center of "The Snow Queen" is Gerda's quest. The graphic artist has not only the pivotal bad guys, but also a cast of varied characters to illustrate: the well-meaning Crow, the Woman Who Knew Magic with her magical flower garden, the little Robber Girl with her ill-treated menagerie and her gruesome mother, and the anxious Reindeer. Frame by frame, as Gerda searches for Kay, you see her grow up.

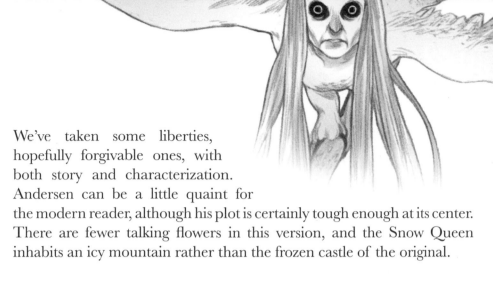

We've taken some liberties, hopefully forgivable ones, with both story and characterization. Andersen can be a little quaint for the modern reader, although his plot is certainly tough enough at its center. There are fewer talking flowers in this version, and the Snow Queen inhabits an icy mountain rather than the frozen castle of the original.

The Queen herself has probably undergone the biggest change: those familiar with the original story will remember her snowflake robes and unearthly beauty, glamorous but illusory, masking her true character. In this retelling, the emphasis is on the Queen as a powerful force of nature, representing the unknown. The sharp-eyed will notice that her "courtier" animals include a crowd of owls, and in dramatic moments, she takes on some aspects of an owl herself, with eyes deep enough to drown in, and grasping hands that look like talons—the gloves literally come off as she turns animalistic and merciless, a true embodiment of winter. There's no doubt that she comes from a very chilly place indeed.

Gerda's adventure, on the other hand, is all about love. She carries Kay's hat, a reminder of her friend, with her until she finds him. Barefoot and vulnerable, she heads into the unknown with all the enthusiasm that she had for her travel books back at home. She unquestioningly cares for those she meets, and unexpectedly it's her trust and openness that lend her strength and arm her against the Snow Queen, ultimately helping her to win Kay back from the Queen's clutches.

Perhaps the most powerful impression "The Snow Queen" leaves us with is one of cold; the icy backdrop to the tale, rendered beautifully in graphics, recalls the shivery feeling you get after an hour or two on a freezing winter's day out of doors in too-light clothing. We hope this updated version gives you a thrill or two.

DRAMATIS PERSONAE

THE SNOW QUEEN

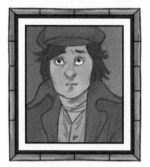

KAY

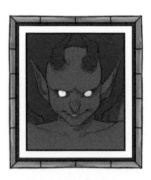

THE DEMON

GERDA

KAY'S GRANDMOTHER

THE SNOW QUEEN

THE CROW

GERDA'S GRANDMOTHER

THE WOMAN
WHO KNEW
MAGIC

THE LITTLE
ROBBER GIRL

THE PRINCE AND PRINCESS

THE LAPLAND
WOMAN

THE FINNISH
WOMAN

REINDEER

CHAPTER
~ ONE ~

MORE THAN A HUNDRED YEARS AGO, IN THE WORKSHOP OF A WICKED AND POWERFUL DEMON...

WHY WON'T HE TELL US WHAT WE'RE MAKING? IS IT A SPELL?

HE SAYS IT'S SOMETHING WICKED...QUITE REMARKABLY WICKED...THE WORST THING EVER MADE.

AND HE'S MADE SOME BAD, BAD THINGS...

ARE YOU WORKING, OR GOSSIPING?

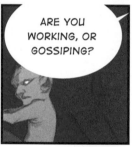

YOU'LL SEE THE RESULTS SOON ENOUGH.

DO WHAT YOU'RE TOLD, OR I'LL TURN YOU INTO SPECKS OF SOOT!

TRULY, IT'S A WORK OF PURE GENIUS...THE DEVIL HIMSELF COULDN'T BETTER IT! NEVER BEFORE HAS ANYONE THOUGHT OF ANYTHING QUITE SO REFINED. HOW ADMIRED AND HOW COURTED I WILL BE!

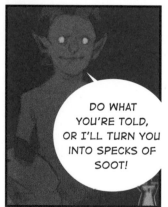

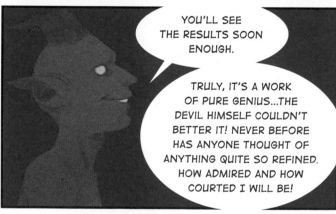

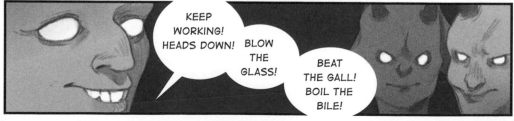

KEEP WORKING! HEADS DOWN!

BLOW THE GLASS!

BEAT THE GALL! BOIL THE BILE!

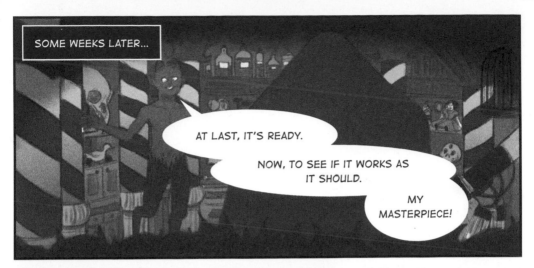

SOME WEEKS LATER...

AT LAST, IT'S READY.

NOW, TO SEE IF IT WORKS AS IT SHOULD.

MY MASTERPIECE!

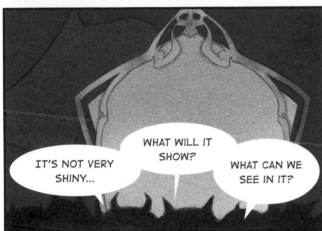

WHAT WILL IT SHOW?

IT'S NOT VERY SHINY...

WHAT CAN WE SEE IN IT?

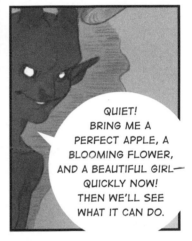

QUIET! BRING ME A PERFECT APPLE, A BLOOMING FLOWER, AND A BEAUTIFUL GIRL— QUICKLY NOW! THEN WE'LL SEE WHAT IT CAN DO.

YES SIR!

STRAIGHT AWAY, SIR!

WELL, HOLD IT UP!

IN THE MIRROR?

OF COURSE IN THE MIRROR, SIMPLETON.

NOW DO YOU COMPREHEND? BRING THE FLOWER!

HOLD IT UP!

OH, MASTER, I THINK I UNDERSTAND.

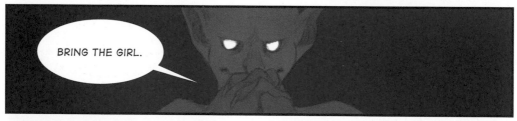

BRING THE GIRL.

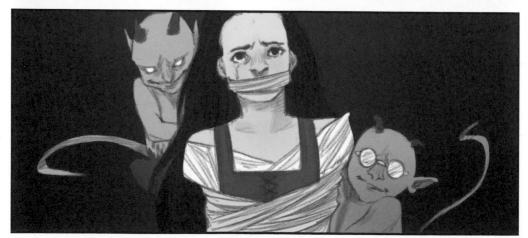

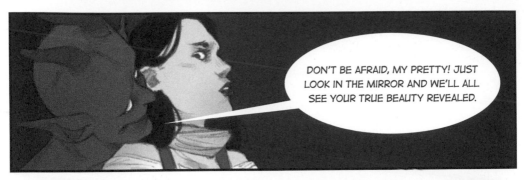

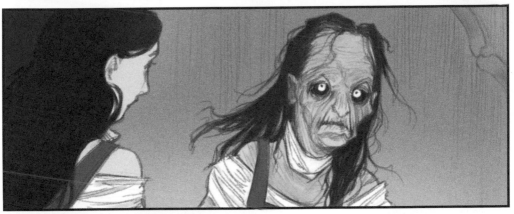

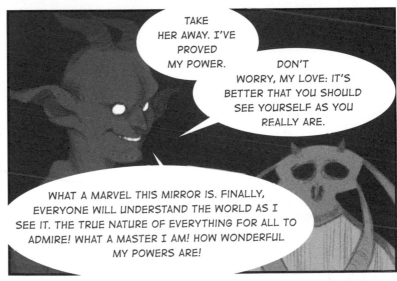

LATER THAT NIGHT...

THAT WASN'T MUCH OF A TRIAL.

RATHER A MEAN DISPLAY OF THE MIRROR'S POWERS.

WHAT IF WE TESTED IT OUT IN THE WORLD?

HE'D BE FURIOUS!

HE'D BLOW US INTO ATOMS! GRAINS OF SOOT!

PAH!

YOU'RE POOR EXCUSES FOR IMPS. DON'T DARE TRY? HE'LL NEVER KNOW.

HE'S GOT EYES IN THE BACK OF HIS HEAD...

HE CAN SEE IN THE DARK...

HE'LL TWIST OUR TAILS AND CUT OFF OUR EARS, I SUPPOSE. COME ON, JUST A QUICK TRIAL. LET'S SEE WHAT THE MOON AND STARS LOOK LIKE. LET'S SEE WHAT THE MIRROR DOES WITH SOMETHING OF SIZE.

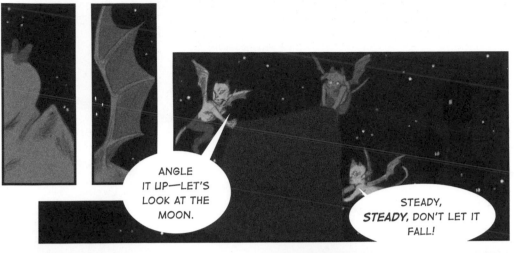

ANGLE IT UP—LET'S LOOK AT THE MOON.

STEADY, **STEADY**, DON'T LET IT FALL!

I'M TURNING IT ROUND...

IT'S JUST DARK! NO LIGHT!

THERE MUST BE MORE EXCITING THINGS TO SHOW.

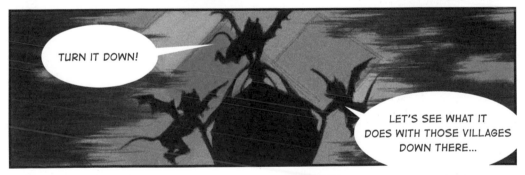

TURN IT DOWN!

LET'S SEE WHAT IT DOES WITH THOSE VILLAGES DOWN THERE...

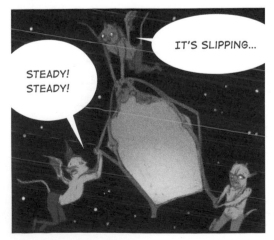

STEADY! STEADY!

IT'S SLIPPING...

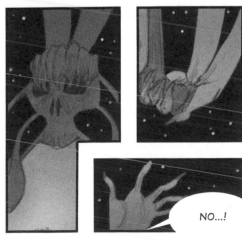

NO...!

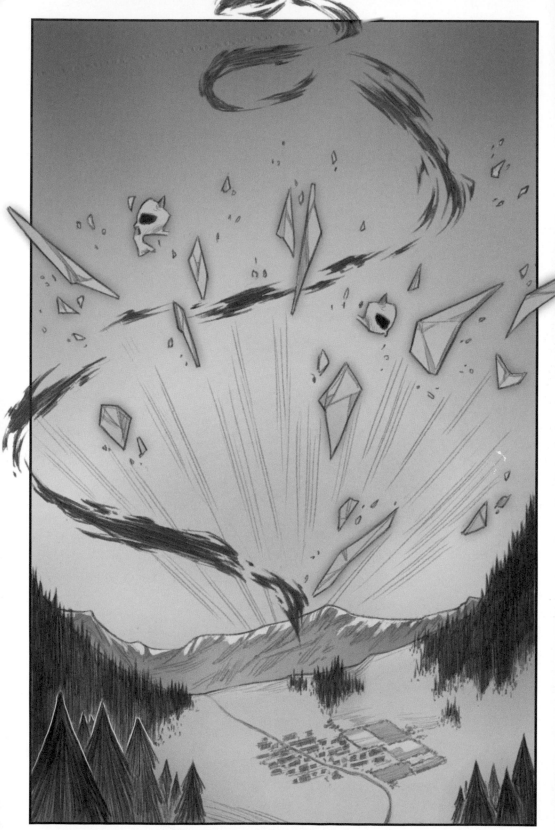

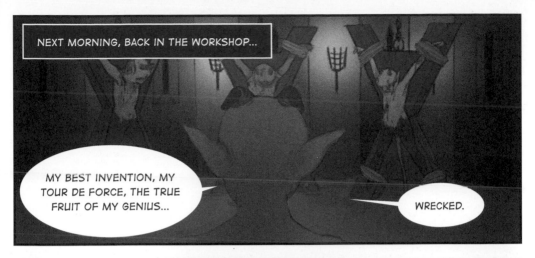

NEXT MORNING, BACK IN THE WORKSHOP...

MY BEST INVENTION, MY TOUR DE FORCE, THE TRUE FRUIT OF MY GENIUS...

WRECKED.

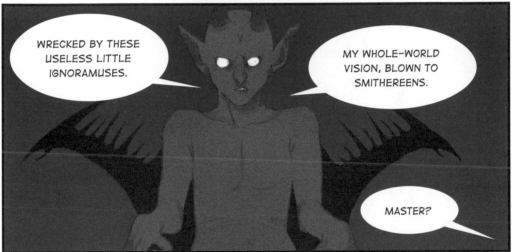

WRECKED BY THESE USELESS LITTLE IGNORAMUSES.

MY WHOLE-WORLD VISION, BLOWN TO SMITHEREENS.

MASTER?

HOW DARE YOU INTERRUPT MY THOUGHTS, YOU CLOD? WHAT DO YOU WANT?

DOWN IN THE WORLD...

WHAT? SPEAK UP, YOU IDIOT MUTE!

DOWN IN THE WORLD, ON THE EARTH, IN THE TOWNS AND VILLAGES, THE MIRROR IS WORKING...

15

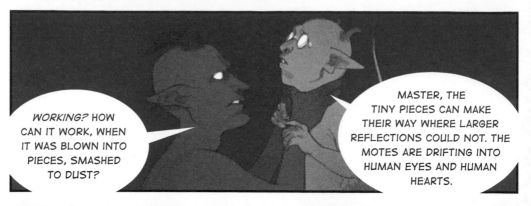

WORKING? HOW CAN IT WORK, WHEN IT WAS BLOWN INTO PIECES, SMASHED TO DUST?

MASTER, THE TINY PIECES CAN MAKE THEIR WAY WHERE LARGER REFLECTIONS COULD NOT. THE MOTES ARE DRIFTING INTO HUMAN EYES AND HUMAN HEARTS.

WHAT? YOU'VE SEEN THIS? AND DO THESE MOTES HAVE AN EFFECT?

A GREAT EFFECT, MASTER!

AN EFFECT YOU'D BE PROUD OF!

FETCH MY GLASS!

LET ME SEE!

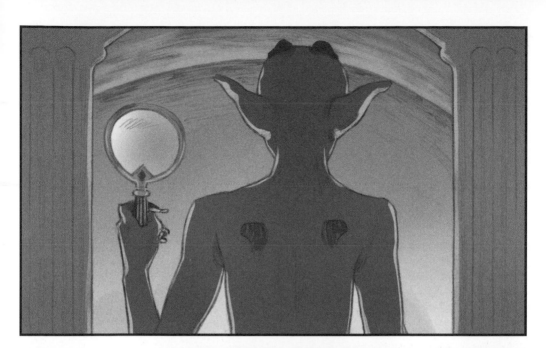

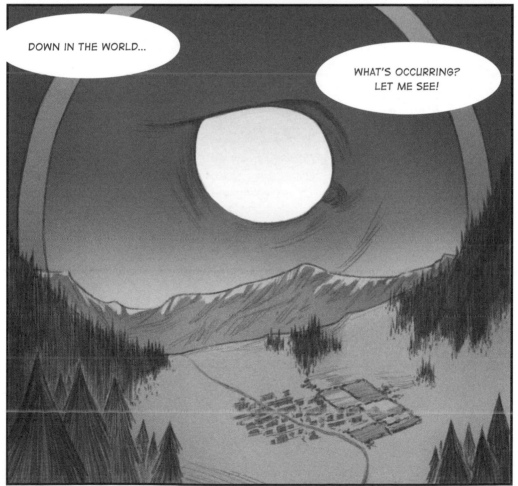

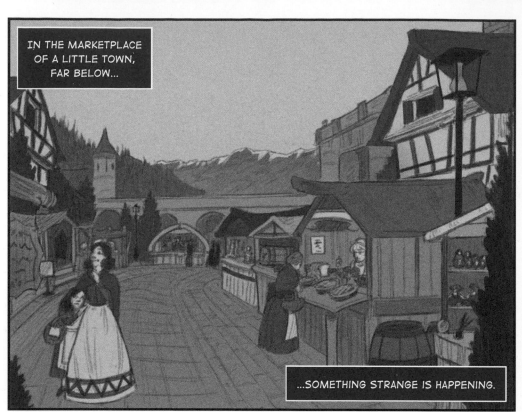

IN THE MARKETPLACE OF A LITTLE TOWN, FAR BELOW...

...SOMETHING STRANGE IS HAPPENING.

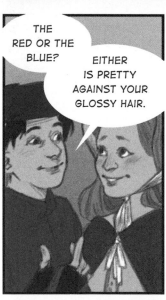

THE RED OR THE BLUE?

EITHER IS PRETTY AGAINST YOUR GLOSSY HAIR.

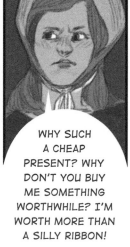

WHY SUCH A CHEAP PRESENT? WHY DON'T YOU BUY ME SOMETHING WORTHWHILE? I'M WORTH MORE THAN A SILLY RIBBON!

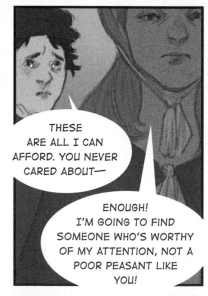

THESE ARE ALL I CAN AFFORD. YOU NEVER CARED ABOUT—

ENOUGH! I'M GOING TO FIND SOMEONE WHO'S WORTHY OF MY ATTENTION, NOT A POOR PEASANT LIKE YOU!

IT'S WORKING!

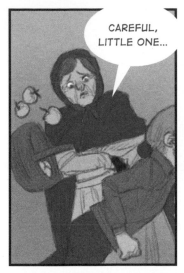

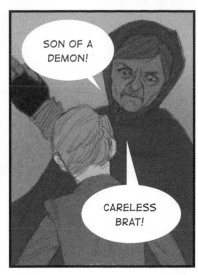

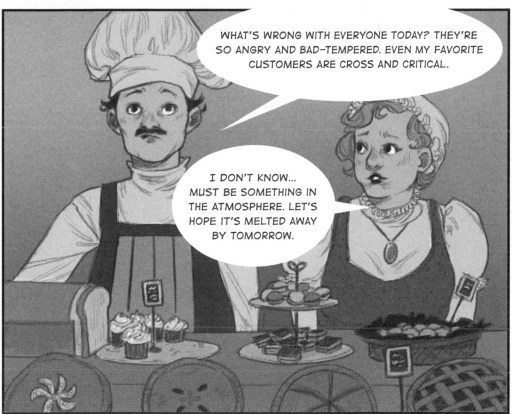

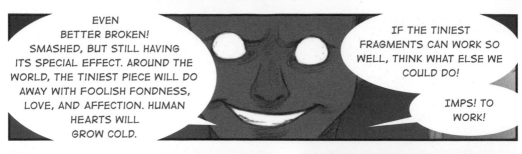

EVEN BETTER BROKEN! SMASHED, BUT STILL HAVING ITS SPECIAL EFFECT. AROUND THE WORLD, THE TINIEST PIECE WILL DO AWAY WITH FOOLISH FONDNESS, LOVE, AND AFFECTION. HUMAN HEARTS WILL GROW COLD.

IF THE TINIEST FRAGMENTS CAN WORK SO WELL, THINK WHAT ELSE WE COULD DO!

IMPS! TO WORK!

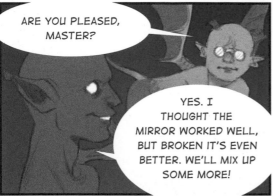

ARE YOU PLEASED, MASTER?

YES. I THOUGHT THE MIRROR WORKED WELL, BUT BROKEN IT'S EVEN BETTER. WE'LL MIX UP SOME MORE!

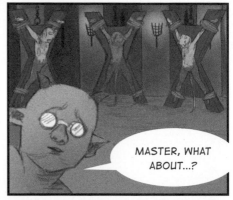

MASTER, WHAT ABOUT...?

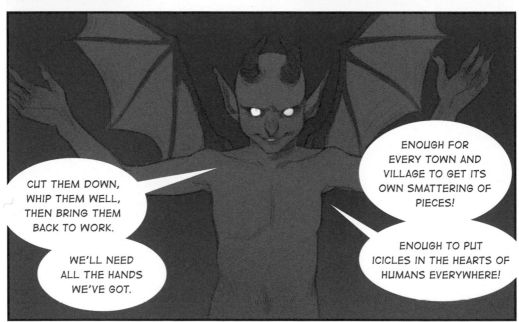

CUT THEM DOWN, WHIP THEM WELL, THEN BRING THEM BACK TO WORK.

WE'LL NEED ALL THE HANDS WE'VE GOT.

ENOUGH FOR EVERY TOWN AND VILLAGE TO GET ITS OWN SMATTERING OF PIECES!

ENOUGH TO PUT ICICLES IN THE HEARTS OF HUMANS EVERYWHERE!

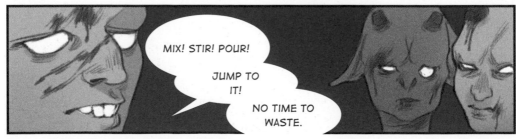

MIX! STIR! POUR!

JUMP TO IT!

NO TIME TO WASTE.

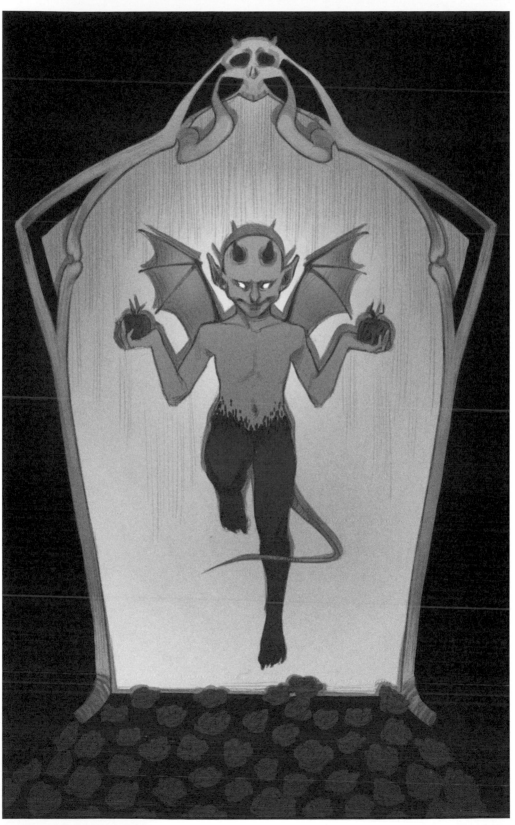

CHAPTER
~ TWO ~

KAY, ARE YOU SEEING GERDA TODAY?

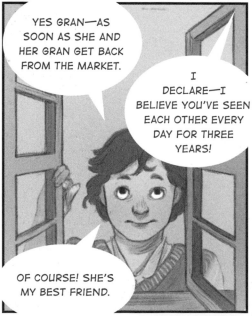

YES GRAN—AS SOON AS SHE AND HER GRAN GET BACK FROM THE MARKET.

I DECLARE—I BELIEVE YOU'VE SEEN EACH OTHER EVERY DAY FOR THREE YEARS!

OF COURSE! SHE'S MY BEST FRIEND.

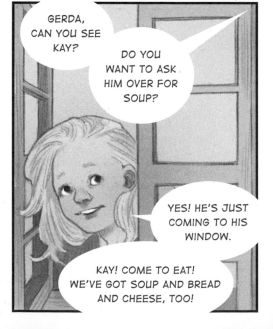

GERDA, CAN YOU SEE KAY?

DO YOU WANT TO ASK HIM OVER FOR SOUP?

YES! HE'S JUST COMING TO HIS WINDOW.

KAY! COME TO EAT! WE'VE GOT SOUP AND BREAD AND CHEESE, TOO!

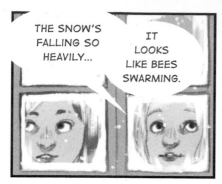

THE SNOW'S FALLING SO HEAVILY...

IT LOOKS LIKE BEES SWARMING.

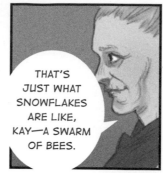

THAT'S JUST WHAT SNOWFLAKES ARE LIKE, KAY—A SWARM OF BEES.

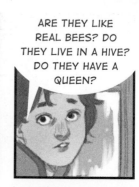

ARE THEY LIKE REAL BEES? DO THEY LIVE IN A HIVE? DO THEY HAVE A QUEEN?

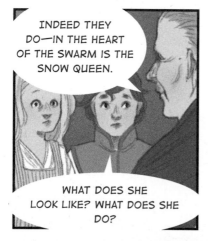

INDEED THEY DO—IN THE HEART OF THE SWARM IS THE SNOW QUEEN.

WHAT DOES SHE LOOK LIKE? WHAT DOES SHE DO?

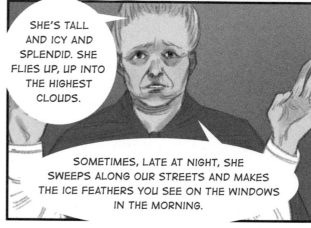

SHE'S TALL AND ICY AND SPLENDID. SHE FLIES UP, UP INTO THE HIGHEST CLOUDS.

SOMETIMES, LATE AT NIGHT, SHE SWEEPS ALONG OUR STREETS AND MAKES THE ICE FEATHERS YOU SEE ON THE WINDOWS IN THE MORNING.

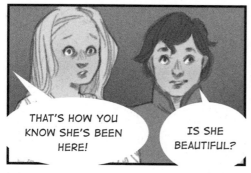

THAT'S HOW YOU KNOW SHE'S BEEN HERE!

IS SHE BEAUTIFUL?

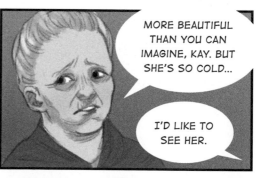

MORE BEAUTIFUL THAN YOU CAN IMAGINE, KAY. BUT SHE'S SO COLD...

I'D LIKE TO SEE HER.

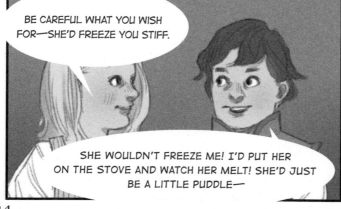

BE CAREFUL WHAT YOU WISH FOR—SHE'D FREEZE YOU STIFF.

SHE WOULDN'T FREEZE ME! I'D PUT HER ON THE STOVE AND WATCH HER MELT! SHE'D JUST BE A LITTLE PUDDLE—

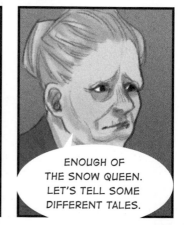

ENOUGH OF THE SNOW QUEEN. LET'S TELL SOME DIFFERENT TALES.

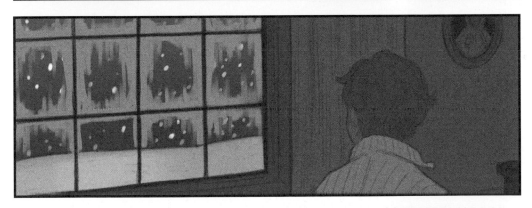

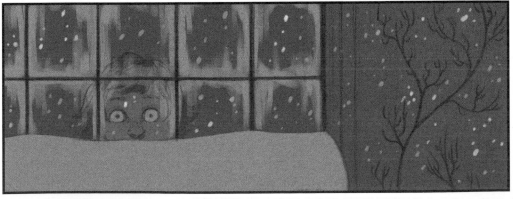

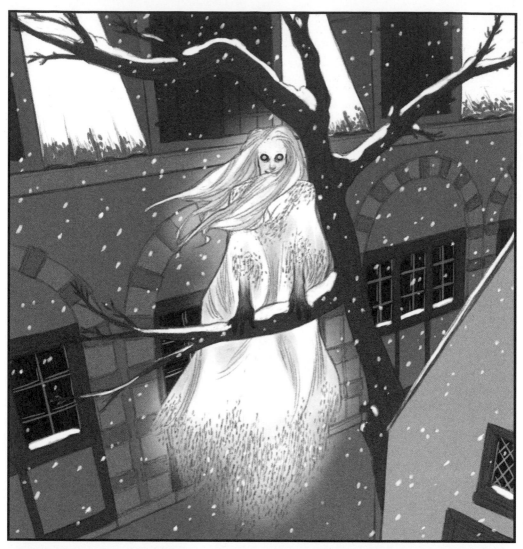

KAY?

KAY!

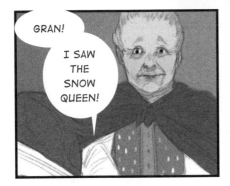

GRAN!

I SAW THE SNOW QUEEN!

YOU WERE DREAMING, KAY. YOU'VE BEEN THINKING TOO MUCH OF THE OLD TALES WE WERE TELLING.

I TELL YOU, I SAW HER! SHE WAS SO BEAUTIFUL, GRAN...

IT'S LIKE YOUR GRAN SAYS, YOU MUST HAVE BEEN DREAMING.

I TOLD YOU, I WASN'T!

TELL ME AGAIN.

I THOUGHT AT LEAST YOU'D BELIEVE ME, GERDA.

SHE WAS TALL AND SPLENDID...ALL IN FURS. HER HAIR LOOKED LIKE SNOWFLAKES...

AND HER FACE?

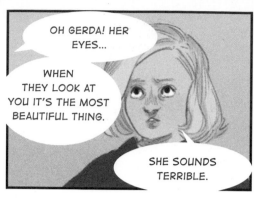

OH GERDA! HER EYES...

WHEN THEY LOOK AT YOU IT'S THE MOST BEAUTIFUL THING.

SHE SOUNDS TERRIBLE.

SHE'S MAGNIFICENT! A BIT FRIGHTENING, MAYBE, BUT POWERFUL AND MARVELOUS.

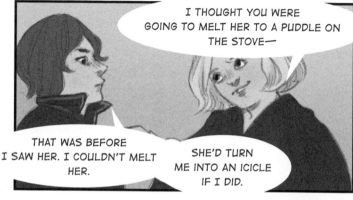

I THOUGHT YOU WERE GOING TO MELT HER TO A PUDDLE ON THE STOVE—

THAT WAS BEFORE I SAW HER. I COULDN'T MELT HER.

SHE'D TURN ME INTO AN ICICLE IF I DID.

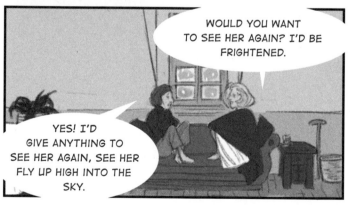

WOULD YOU WANT TO SEE HER AGAIN? I'D BE FRIGHTENED.

YES! I'D GIVE ANYTHING TO SEE HER AGAIN, SEE HER FLY UP HIGH INTO THE SKY.

I COULD DRIVE HER SLED, OR HELP HER MAKE ICE PATTERNS...I COULD LIVE IN HER PALACE AND SERVE HER...

YOU SAID SHE WOULDN'T TROUBLE WITH A KID LIKE YOU!

YOU SHOULD FORGET ABOUT HER. DREAMING ABOUT HER WON'T DO YOU ANY GOOD.

IF YOU COULD ONLY SEE HER...

YOU'D FALL IN LOVE, TOO.

SUMMERTIME, TWO YEARS LATER...

LOOK! THE AMERICAS!

THESE PICTURES OF THE MOUNTAINS AND THE CANYONS.

WHAT ABOUT INDIA? AND CHINA? WE COULD SEE THEM ALL!

WE COULD JOIN UP AS SAILORS—

YOU'D HAVE TO CUT YOUR HAIR.

I COULD PASS AS A BOY. IT WOULDN'T BE HARD.

LOOK AT THIS ONE! THE WALL IN CHINA, THE LONGEST IN THE WORLD!

TWO PEAS IN A POD.

THOUGH I'D BE SURPRISED IF THEY EVER RAN AWAY TO SEA...

MORE LIKELY THEY'LL GET MARRIED AND SET UP HOUSE!

I'LL WAGER THEY MAKE A MATCH OF IT BEFORE THEY TURN EIGHTEEN.

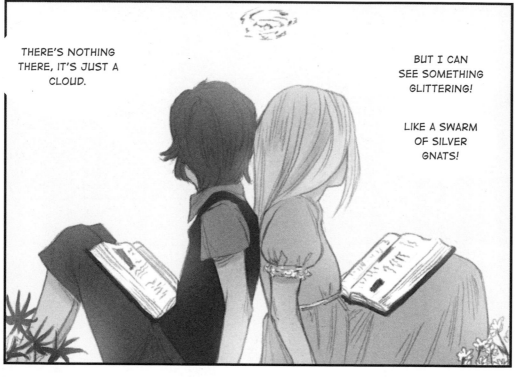

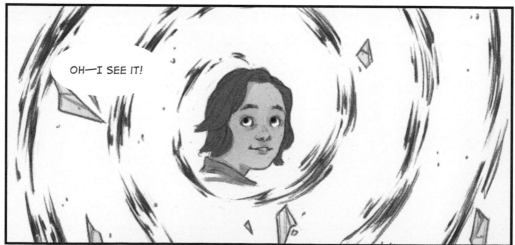

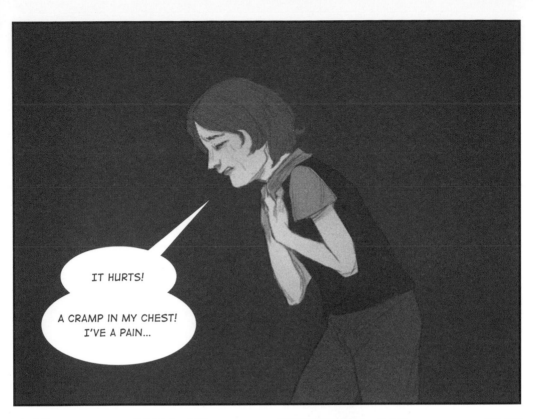

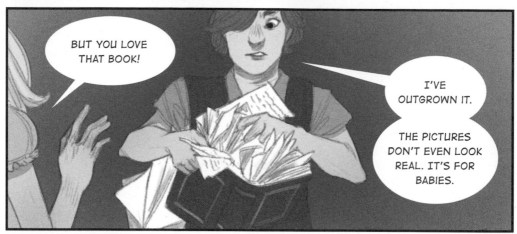

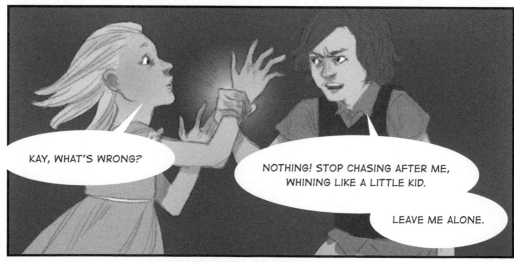

32

IS GERDA ANY BETTER?

SHE'S STILL UPSET.

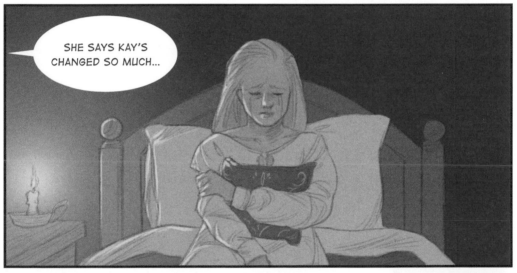

SHE SAYS KAY'S CHANGED SO MUCH...

...SHE DOESN'T EVEN KNOW HIM.

33

IT SEEMS SO SUDDEN...

HE EVEN LOOKS DIFFERENT.

SOME DAYS YOU COULD SWEAR HIS EYES WERE...

...I DON'T KNOW.

MAYBE HE'S JUST GROWING UP?

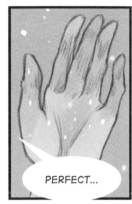

PERFECT...

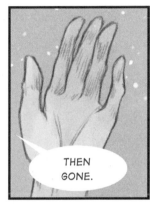

THEN GONE.

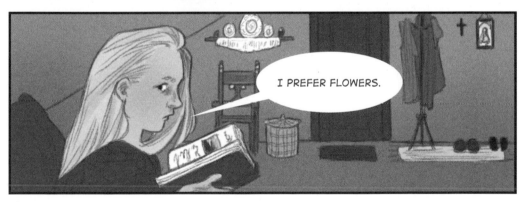

I PREFER FLOWERS.

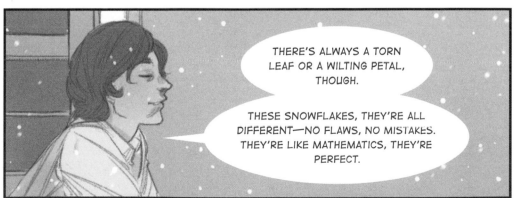

THERE'S ALWAYS A TORN LEAF OR A WILTING PETAL, THOUGH.

THESE SNOWFLAKES, THEY'RE ALL DIFFERENT—NO FLAWS, NO MISTAKES. THEY'RE LIKE MATHEMATICS, THEY'RE PERFECT.

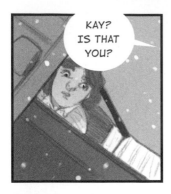

KAY? IS THAT YOU?

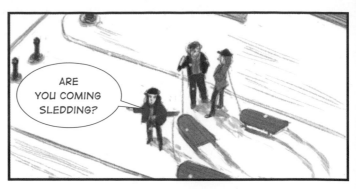

ARE YOU COMING SLEDDING?

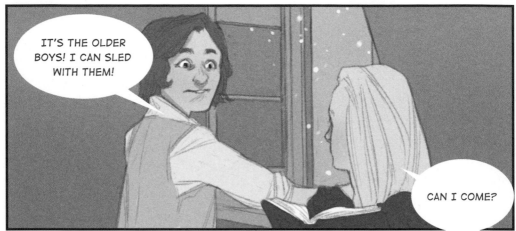

IT'S THE OLDER BOYS! I CAN SLED WITH THEM!

CAN I COME?

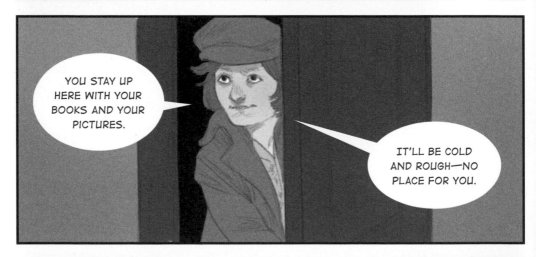

YOU STAY UP HERE WITH YOUR BOOKS AND YOUR PICTURES.

IT'LL BE COLD AND ROUGH—NO PLACE FOR YOU.

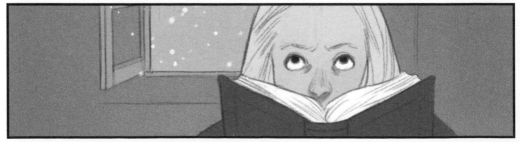

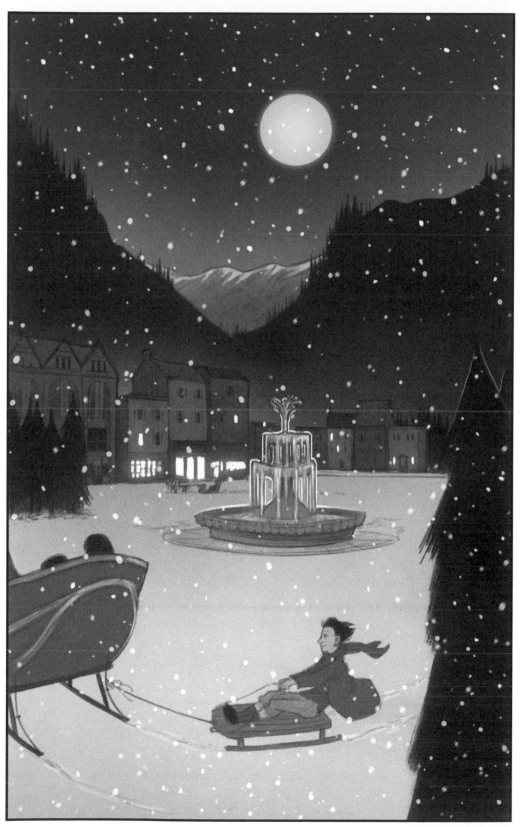

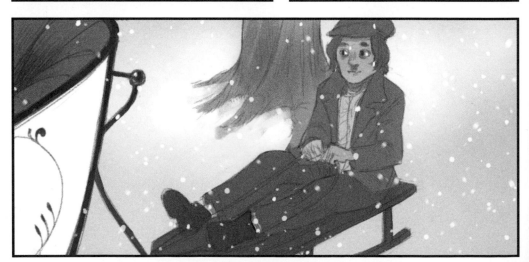

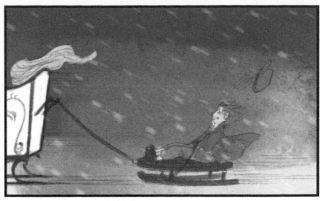

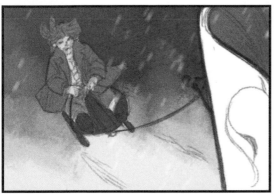

HUH?

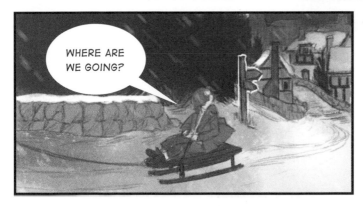

WHERE ARE
WE GOING?

WHOA...

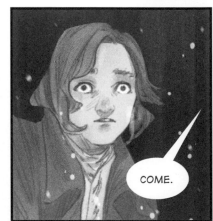

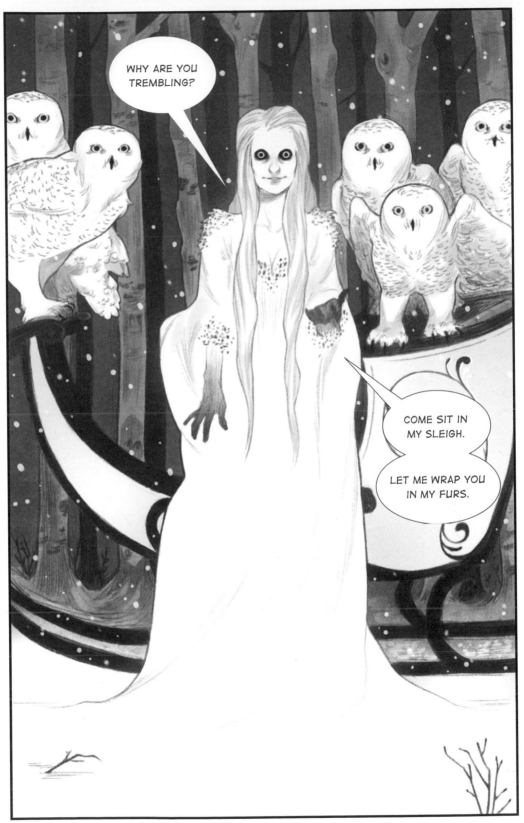

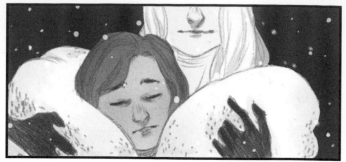
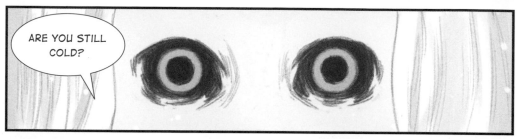
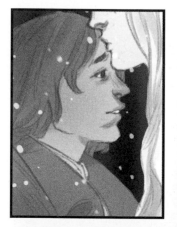

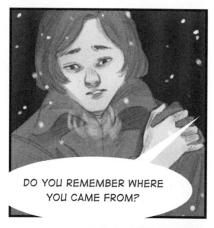
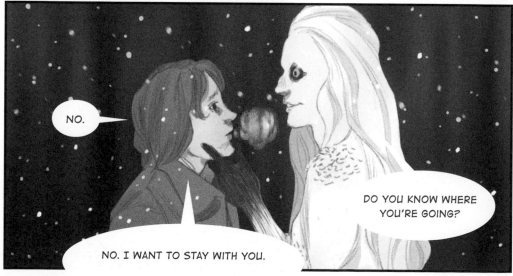

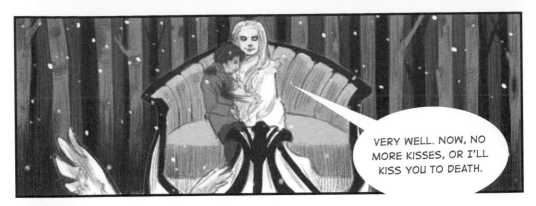

VERY WELL. NOW, NO MORE KISSES, OR I'LL KISS YOU TO DEATH.

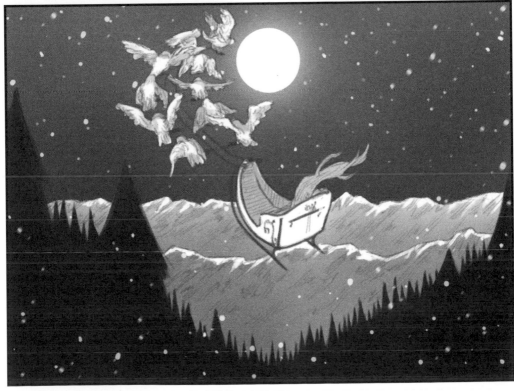

CHAPTER
~ THREE ~

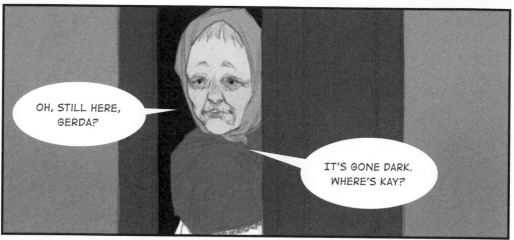

OH, STILL HERE, GERDA?

IT'S GONE DARK. WHERE'S KAY?

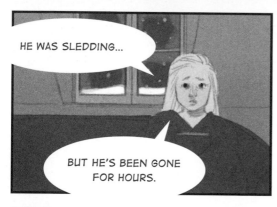

HE WAS SLEDDING...

BUT HE'S BEEN GONE FOR HOURS.

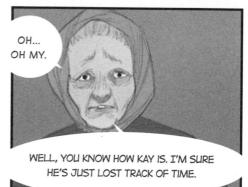

OH... OH MY.

WELL, YOU KNOW HOW KAY IS. I'M SURE HE'S JUST LOST TRACK OF TIME.

YOU'D BETTER GET YOURSELF HOME, DEAR.

IT'S ICY COLD. YOUR GRANDMOTHER WILL START TO WORRY.

DID YOU HEAR?

THE BOY WHO LIVES THERE HAS GONE MISSING.

THEY FOUND HIS CAP DOWN BY THE LAKE.

YOU DON'T THINK MAYBE HE DROWNED?

IT WAS WINTER, THOUGH. WOULDN'T THE LAKE HAVE BEEN FROZEN OVER?

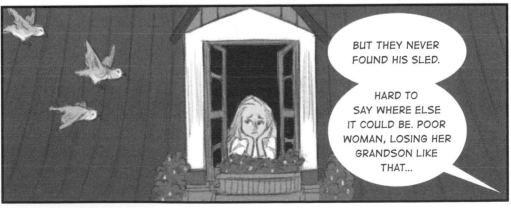

BUT THEY NEVER FOUND HIS SLED.

HARD TO SAY WHERE ELSE IT COULD BE. POOR WOMAN, LOSING HER GRANDSON LIKE THAT...

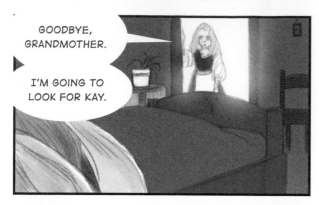

GOODBYE, GRANDMOTHER.

I'M GOING TO LOOK FOR KAY.

I'LL BE BACK SOON.

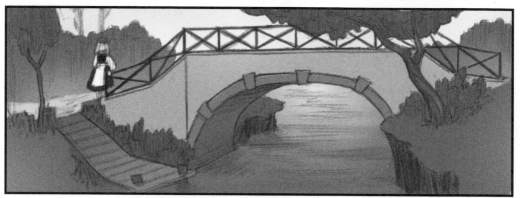

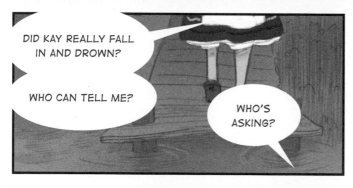

DID KAY REALLY FALL IN AND DROWN?

WHO CAN TELL ME?

WHO'S ASKING?

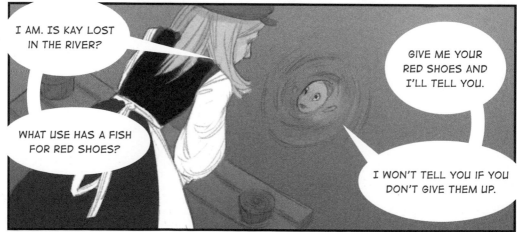

I AM. IS KAY LOST IN THE RIVER?

WHAT USE HAS A FISH FOR RED SHOES?

GIVE ME YOUR RED SHOES AND I'LL TELL YOU.

I WON'T TELL YOU IF YOU DON'T GIVE THEM UP.

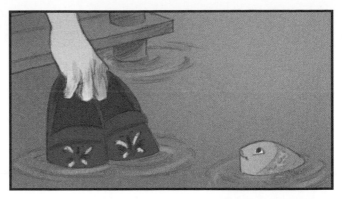

WAIT—WHERE ARE YOU GOING?

OH?

IS THIS FOR ME?

BUT WHERE AM I GOING?

CAW!

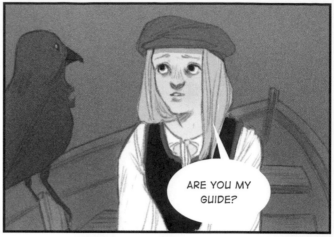

ARE YOU MY GUIDE?

CAW! KAY'S NOT IN THE RIVER. YOU'VE GOT A LONG WAY TO GO YET.

BUT WE'RE ALREADY OUT OF TOWN! HOW MUCH FARTHER COULD HE BE?

FARTHER THAN YOU'VE EVER BEEN BEFORE.

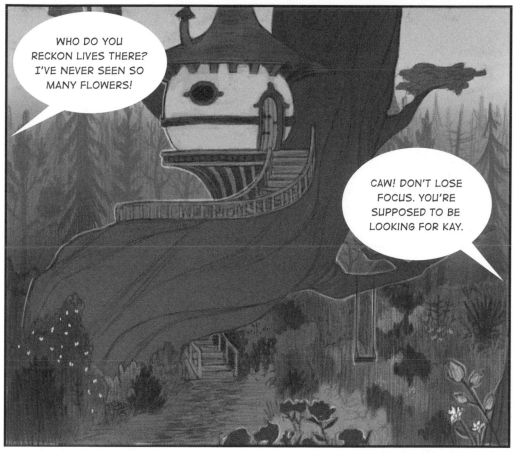

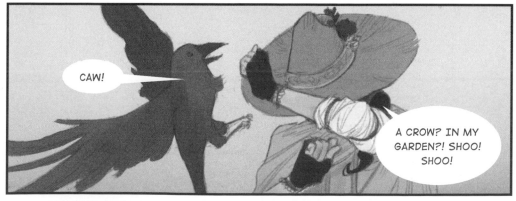

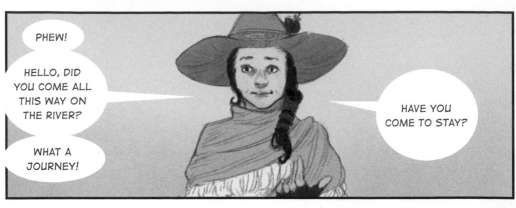

PHEW!

HELLO, DID YOU COME ALL THIS WAY ON THE RIVER?

WHAT A JOURNEY!

HAVE YOU COME TO STAY?

I HAVEN'T COME TO STAY, BUT I'D LIKE A REST.

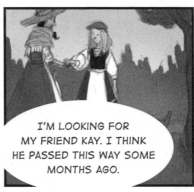

I'M LOOKING FOR MY FRIEND KAY. I THINK HE PASSED THIS WAY SOME MONTHS AGO.

COME IN, EAT AND REST. WE CAN TALK ABOUT IT.

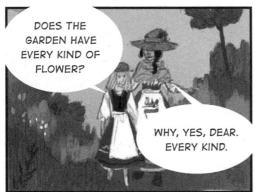

DOES THE GARDEN HAVE EVERY KIND OF FLOWER?

WHY, YES, DEAR. EVERY KIND.

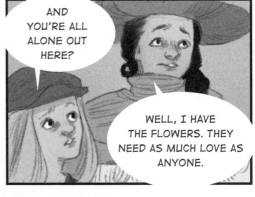

AND YOU'RE ALL ALONE OUT HERE?

WELL, I HAVE THE FLOWERS. THEY NEED AS MUCH LOVE AS ANYONE.

GO AHEAD, EAT AND DRINK!

ALL THIS IS GROWN HERE.

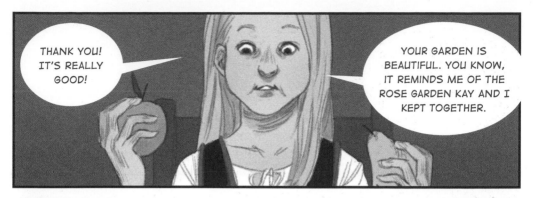

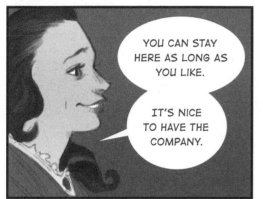

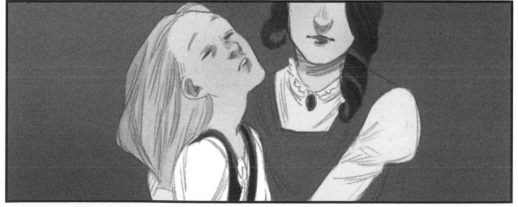

POOR CHILD. HER SEARCH IS FUTILE. WHO KNOWS WHERE HER KAY MIGHT BE?

IF SHE'S TO STAY WITH ME...YES...I'LL NEED TO MAKE A FEW ALTERATIONS.

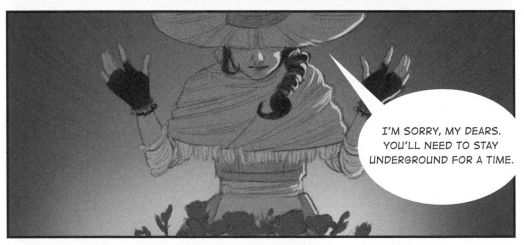

I'M SORRY, MY DEARS. YOU'LL NEED TO STAY UNDERGROUND FOR A TIME.

CAW!

GERDA?

GERDA?

WHERE AM I NOW? HOW LONG WAS I ASLEEP?

YOU LOOKED TIRED, MY LOVE. I LET YOU SLEEP.

BUT NOW IT'S TIME FOR SOME FOOD. AND YOU CAN HELP ME IN THE GARDEN, IF YOU'RE FEELING UP TO IT.

IN MY DREAMS I SAW THINGS...A BOAT ON A RIVER, A BIRD...A ROOFTOP GARRET. HAVE I ALWAYS BEEN HERE?

ALMOST ALWAYS, MY DEAR. YOU WERE ONLY DREAMING.

CAW!

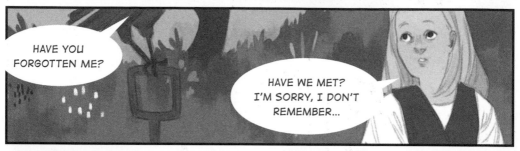

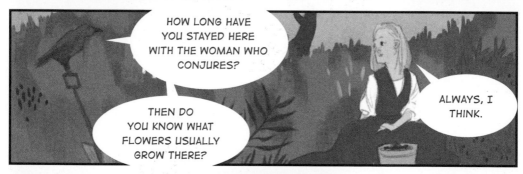

YOU PICKED SOME WONDERFUL BLACKBERRIES TODAY, GERDA.

I'LL SHOW YOU HOW TO MAKE JAM FROM THEM TOMORROW.

I'D LOVE THAT.

I...UM...FOUND AN EMPTY PLOT TODAY. I COULDN'T REMEMBER WHAT USED TO BE THERE.

WELL NO WONDER YOU DON'T REMEMBER! NOTHING HAS GROWN IN THAT PLOT FOR YEARS.

IT'S JUST...THE CROW SEEMED TO THINK...

THAT CROW AGAIN! IF I SEE THAT MEDDLESOME BIRD IN MY GARDEN ONE MORE TIME I'LL BURY HIM IN IT.

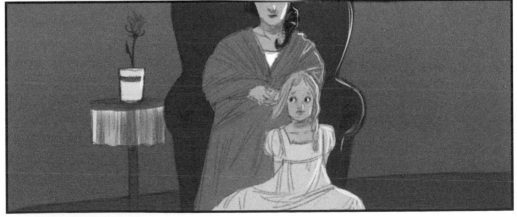

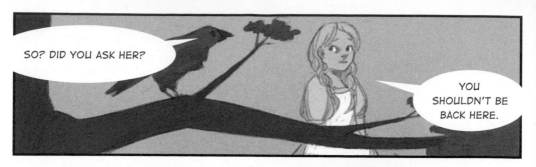

SO? DID YOU ASK HER?

YOU SHOULDN'T BE BACK HERE.

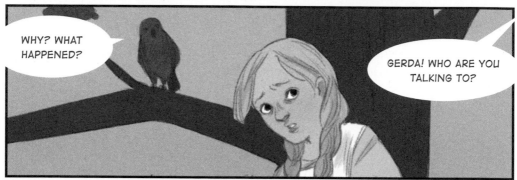

WHY? WHAT HAPPENED?

GERDA! WHO ARE YOU TALKING TO?

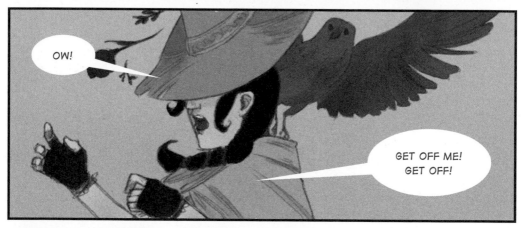

OW!

GET OFF ME! GET OFF!

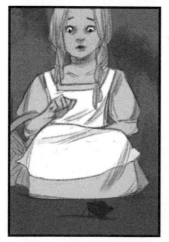

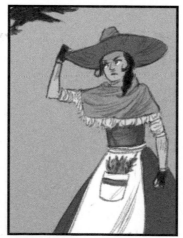

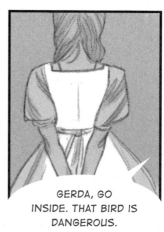

GERDA, GO INSIDE. THAT BIRD IS DANGEROUS.

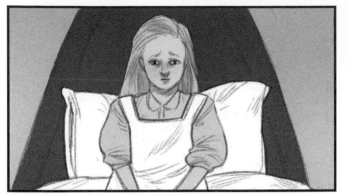

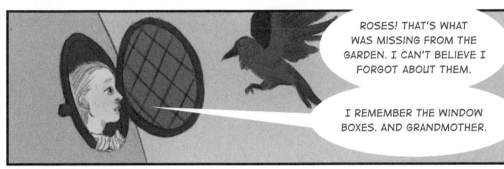

ROSES! THAT'S WHAT WAS MISSING FROM THE GARDEN. I CAN'T BELIEVE I FORGOT ABOUT THEM.

I REMEMBER THE WINDOW BOXES. AND GRANDMOTHER.

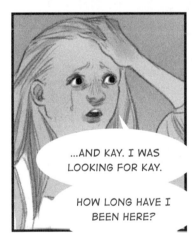

...AND KAY. I WAS LOOKING FOR KAY.

HOW LONG HAVE I BEEN HERE?

I TOLD YOU NOT TO LOSE YOUR FOCUS.

THE WOMAN WHO CONJURES MAY BE LONELY, BUT YOU HAVE A JOB TO DO.

WHAT DO WE DO NOW?

SHE'S GONE DOWN TO THE WELL. WE HAVE TO GO NOW!

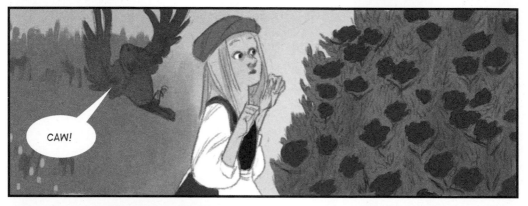

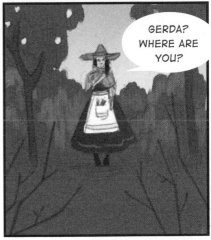

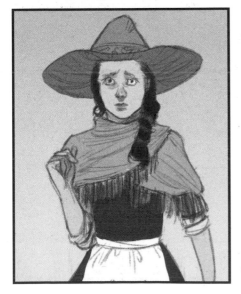

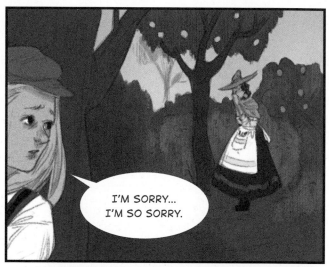

I'M SORRY...
I'M SO SORRY.

CHAPTER
~ FOUR ~

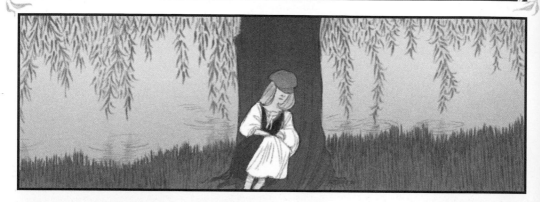

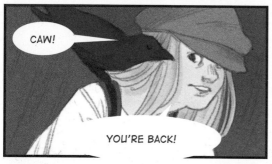

CAW!

YOU'RE BACK!

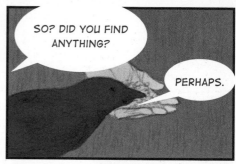

SO? DID YOU FIND ANYTHING?

PERHAPS.

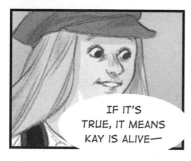

IF IT'S TRUE, IT MEANS KAY IS ALIVE—

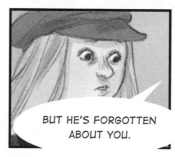

BUT HE'S FORGOTTEN ABOUT YOU.

HE LIVES WITH A BEAUTIFUL PRINCESS.

I SUPPOSE I DID FORGET HIM, TOO...

TELL ME MORE, CROW. WHAT HAPPENED?

THIS LAND WE'RE WALKING THROUGH IS RULED BY A VERY CLEVER PRINCESS.

SHE'S ONLY YOUR AGE BUT SHE'S MONSTROUSLY LEARNED.

BUT SHE WAS LONELY. SHE WANTED A PARTNER.

SO SHE GATHERED HER COURT TOGETHER AND ASKED THEM WHERE SHE COULD FIND ONE.

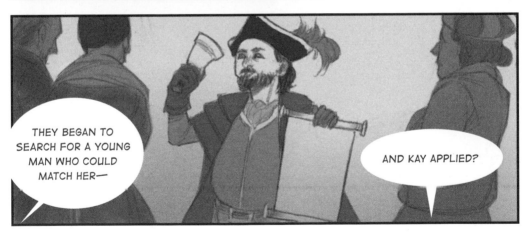

THEY BEGAN TO SEARCH FOR A YOUNG MAN WHO COULD MATCH HER—

AND KAY APPLIED?

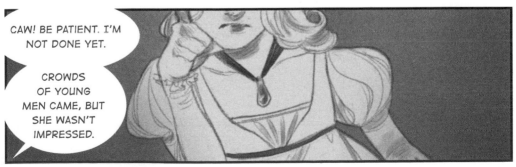

CAW! BE PATIENT. I'M NOT DONE YET.

CROWDS OF YOUNG MEN CAME, BUT SHE WASN'T IMPRESSED.

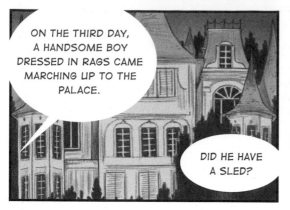

ON THE THIRD DAY, A HANDSOME BOY DRESSED IN RAGS CAME MARCHING UP TO THE PALACE.

DID HE HAVE A SLED?

CAW! STOP INTERRUPTING!

NO SLED, JUST A KNAPSACK. HE WALKED STRAIGHT IN, HE WASN'T SHY.

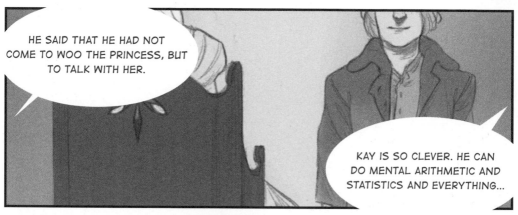

HE SAID THAT HE HAD NOT COME TO WOO THE PRINCESS, BUT TO TALK WITH HER.

KAY IS SO CLEVER. HE CAN DO MENTAL ARITHMETIC AND STATISTICS AND EVERYTHING...

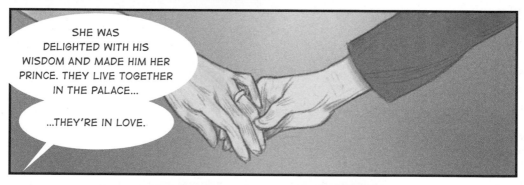

SHE WAS DELIGHTED WITH HIS WISDOM AND MADE HIM HER PRINCE. THEY LIVE TOGETHER IN THE PALACE...

...THEY'RE IN LOVE.

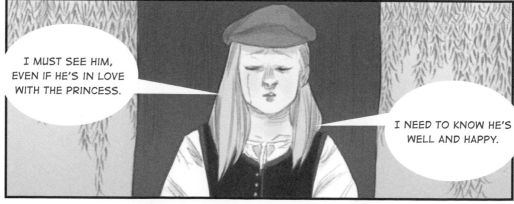

I MUST SEE HIM, EVEN IF HE'S IN LOVE WITH THE PRINCESS.

I NEED TO KNOW HE'S WELL AND HAPPY.

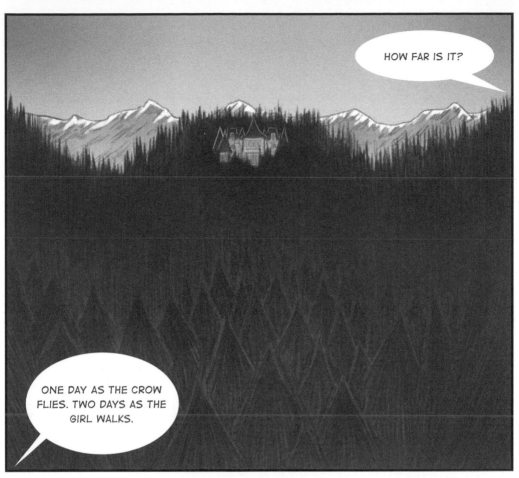

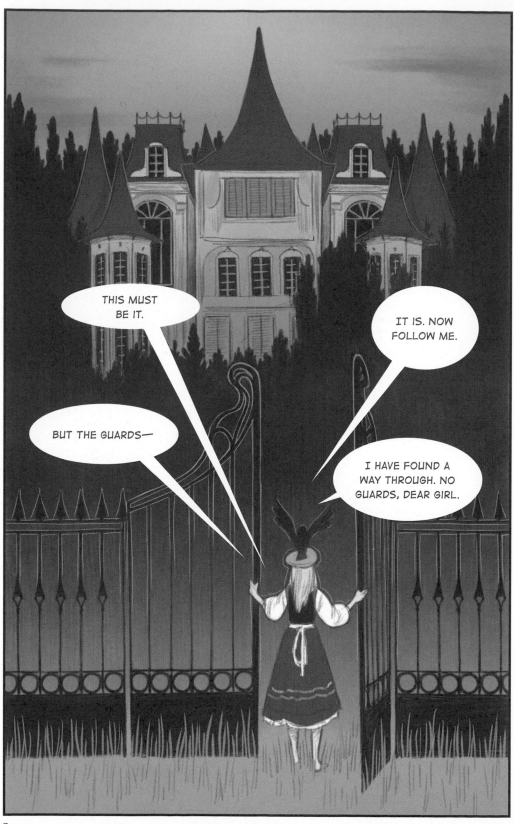

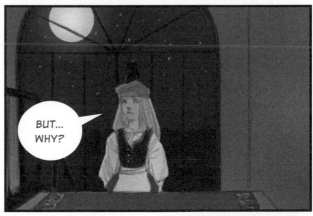

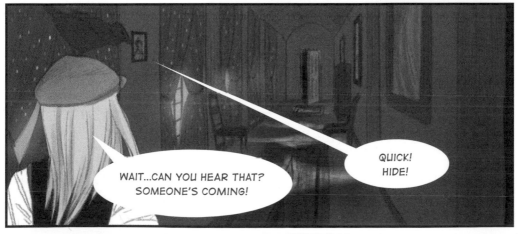

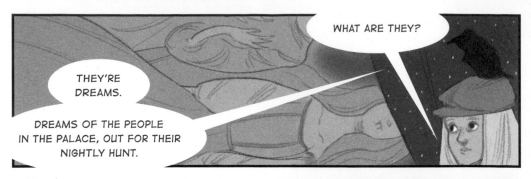

WHAT ARE THEY?

THEY'RE DREAMS.

DREAMS OF THE PEOPLE IN THE PALACE, OUT FOR THEIR NIGHTLY HUNT.

THIS WAY!

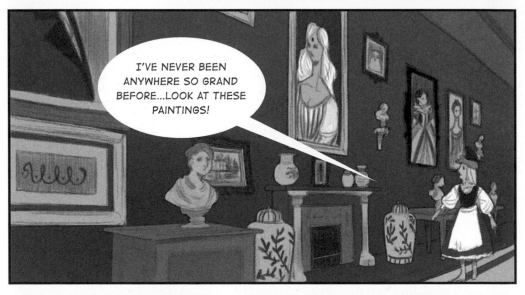

I'VE NEVER BEEN ANYWHERE SO GRAND BEFORE...LOOK AT THESE PAINTINGS!

CAW! THERE'S A HIDDEN DOOR BEHIND THAT ONE.

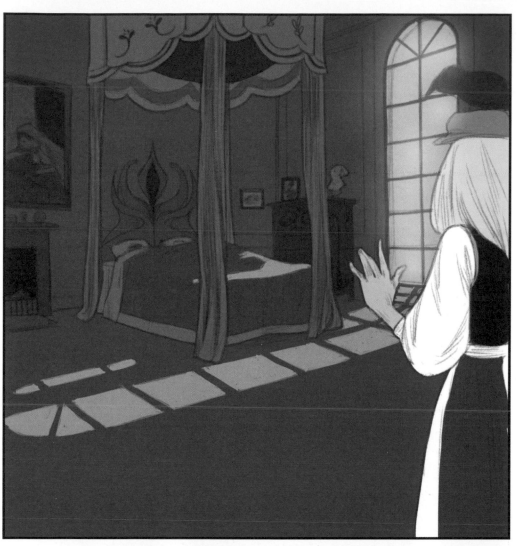

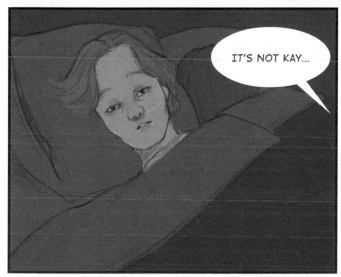

IT'S NOT KAY...

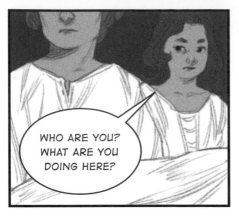

WHO ARE YOU? WHAT ARE YOU DOING HERE?

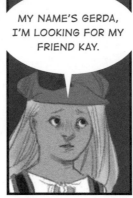

MY NAME'S GERDA, I'M LOOKING FOR MY FRIEND KAY.

I THOUGHT YOU WERE HIM.

TELL US EVERYTHING.

AND SO KAY TOLD THEM HER TALE...

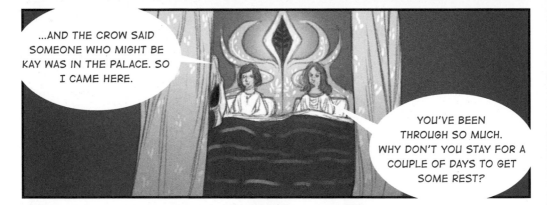

...AND THE CROW SAID SOMEONE WHO MIGHT BE KAY WAS IN THE PALACE. SO I CAME HERE.

YOU'VE BEEN THROUGH SO MUCH. WHY DON'T YOU STAY FOR A COUPLE OF DAYS TO GET SOME REST?

THANK YOU, BUT I NEED TO FIND HIM.

AT LEAST GET SOME REST UNTIL MORNING.

THEN WE CAN SEE WHAT WE CAN DO TO HELP YOU.

MY FEET HURT SO MUCH BEFORE.

THESE BOOTS WILL HELP ME WALK FOREVER!

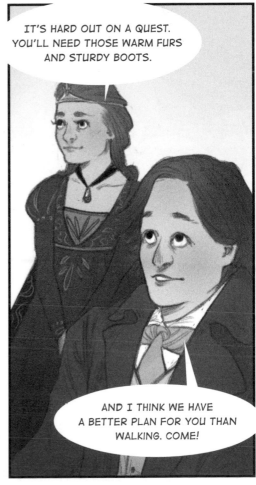

IT'S HARD OUT ON A QUEST. YOU'LL NEED THOSE WARM FURS AND STURDY BOOTS.

AND I THINK WE HAVE A BETTER PLAN FOR YOU THAN WALKING. COME!

I MUST LEAVE YOU HERE.

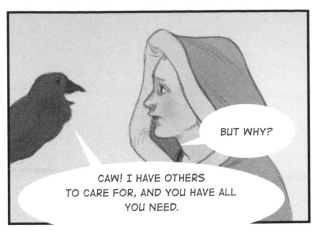

BUT WHY?

CAW! I HAVE OTHERS TO CARE FOR, AND YOU HAVE ALL YOU NEED.

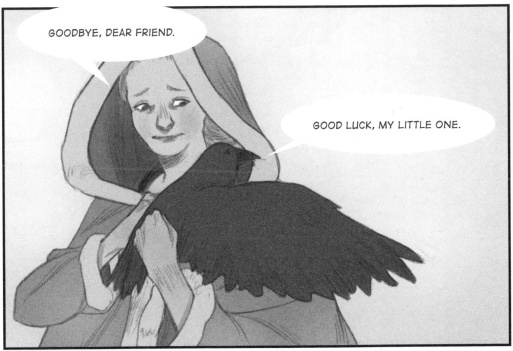

GOODBYE, DEAR FRIEND.

GOOD LUCK, MY LITTLE ONE.

CHAPTER
~ FIVE ~

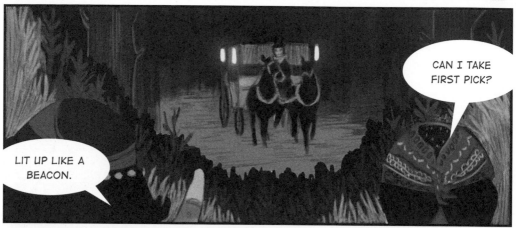

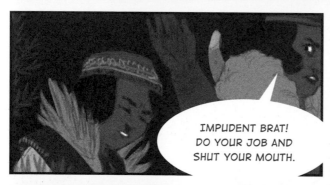

CAN I TAKE FIRST PICK?

LIT UP LIKE A BEACON.

IMPUDENT BRAT! DO YOUR JOB AND SHUT YOUR MOUTH.

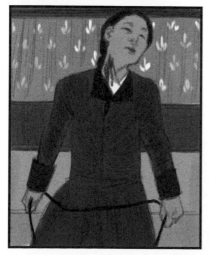

75

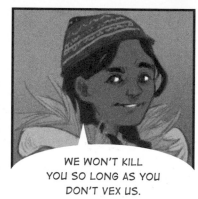

WE WON'T KILL YOU SO LONG AS YOU DON'T VEX US.

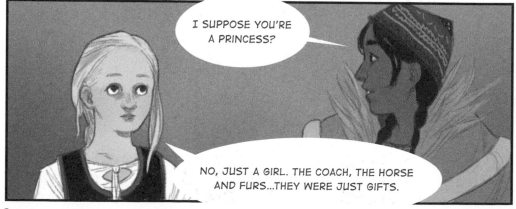

I SUPPOSE YOU'RE A PRINCESS?

NO, JUST A GIRL. THE COACH, THE HORSE AND FURS...THEY WERE JUST GIFTS.

YOU'LL BE SLEEPING HERE WITH ME.

WITH ALL THESE ANIMALS, TOO?

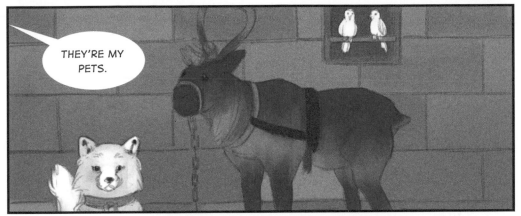

THEY'RE MY PETS.

WATCH THIS!

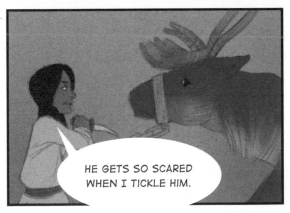

HE GETS SO SCARED WHEN I TICKLE HIM.

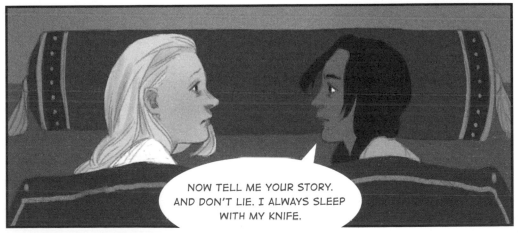

NOW TELL ME YOUR STORY. AND DON'T LIE. I ALWAYS SLEEP WITH MY KNIFE.

WELL YOU TELL A GOOD TALE, EVEN IF YOU ARE A LIAR.

I'M NOT A LIAR.

OO, COO. WE HAVE SEEN LITTLE KAY.

THE SNOW QUEEN TOOK HIM AWAY IN HER SLEIGH. SHE BLEW ON OUR NEST, ONLY WE TWO SURVIVED.

WHAT?! WHERE WAS THE SNOW QUEEN GOING?

TO LAPLAND, WHERE IT'S ALWAYS WINTER. ASK THE REINDEER, HE KNOWS! COO, COO!

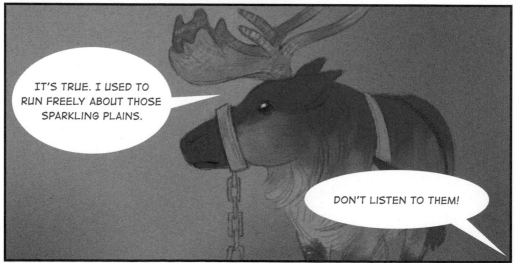

IT'S TRUE. I USED TO RUN FREELY ABOUT THOSE SPARKLING PLAINS.

DON'T LISTEN TO THEM!

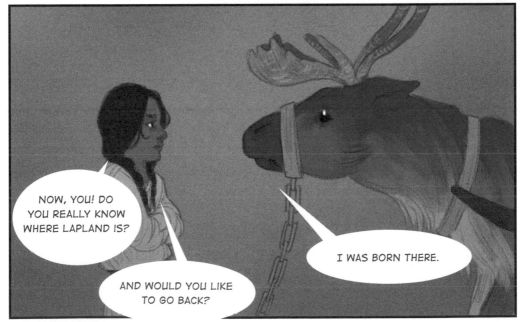

I DREAM OF IT EVERY NIGHT.

WELL, YOU MAY BE IN LUCK—I HAVE A PLAN.

I DON'T LIKE POINTLESS KINDNESS. BUT I'LL HELP YOU.

YOU'D LET ME ESCAPE? YOU'D HELP ME?

STEADY, IT'S NOT THAT SIMPLE.

THE DIFFICULTY IS TO DO IT WITHOUT ANYONE KILLING YOU FIRST.

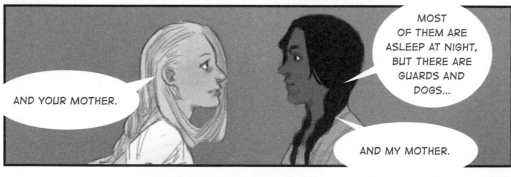

MOST OF THEM ARE ASLEEP AT NIGHT, BUT THERE ARE GUARDS AND DOGS...

AND YOUR MOTHER.

AND MY MOTHER.

SHE WATCHES ME AS CLOSELY AS I WATCH YOU.

EXCEPT...

...WHEN SHE DRINKS THIS STUFF.

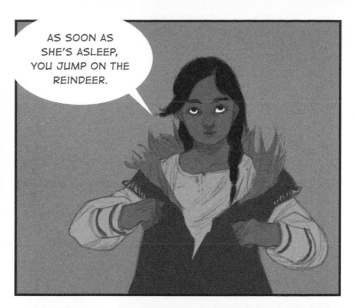

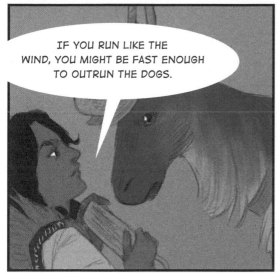

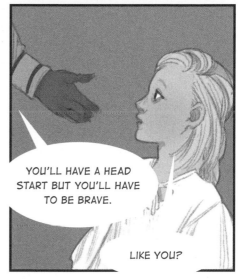

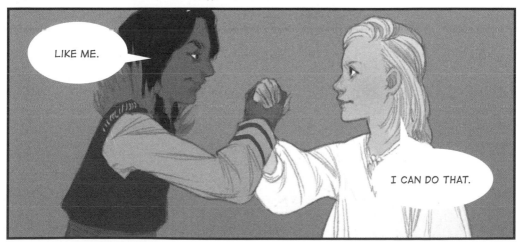

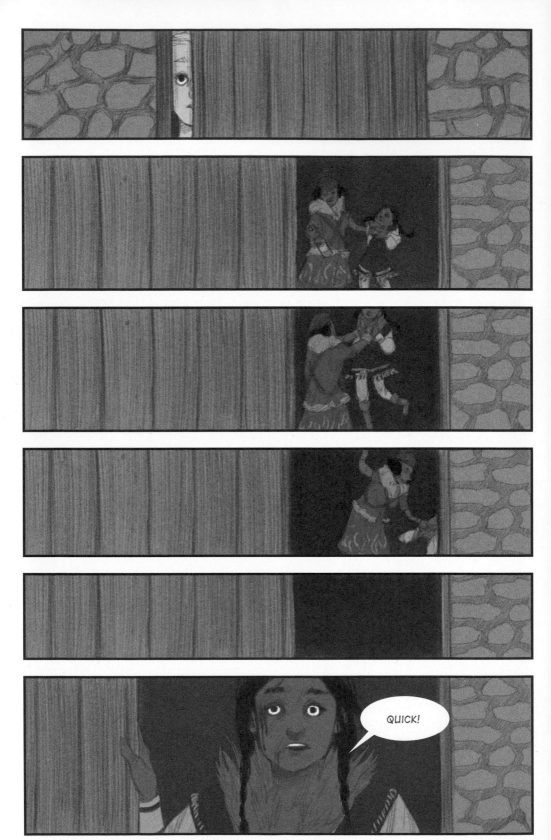

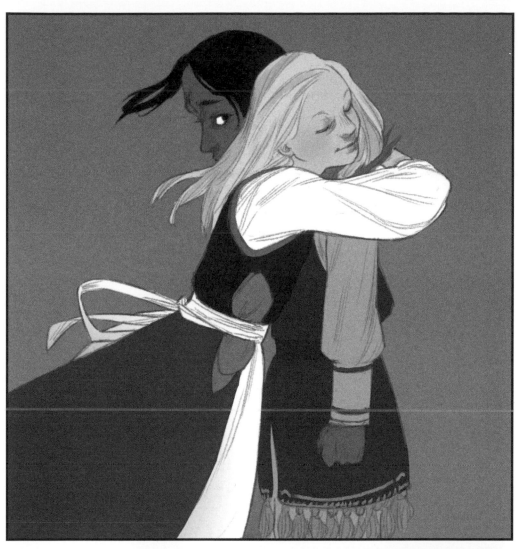

GO!
AND GO FAST...

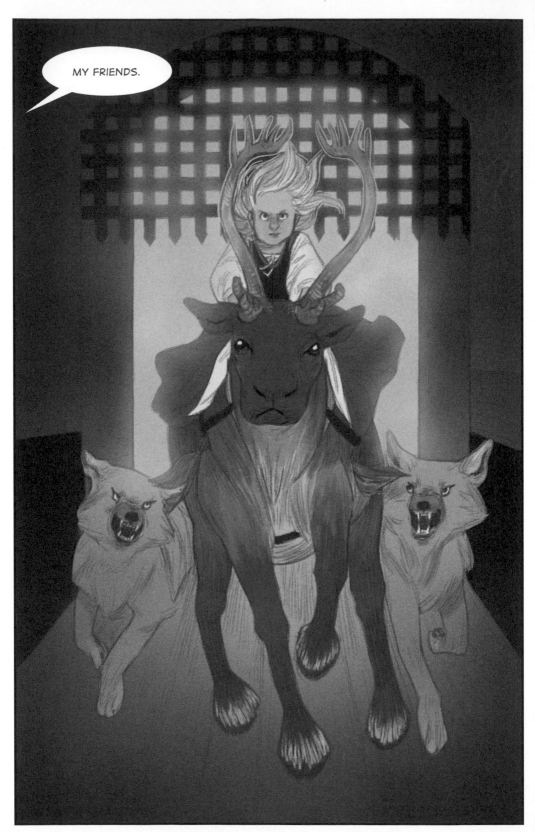

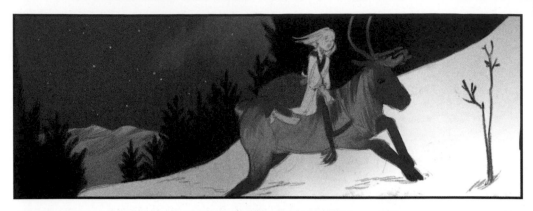

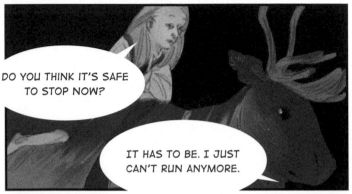

DO YOU THINK IT'S SAFE TO STOP NOW?

IT HAS TO BE. I JUST CAN'T RUN ANYMORE.

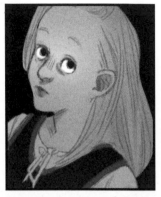

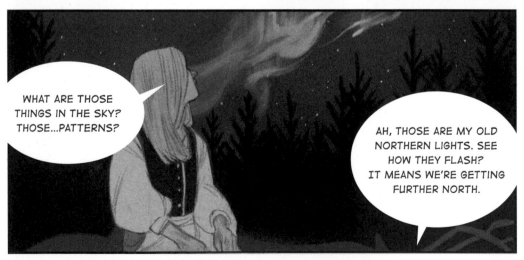

WHAT ARE THOSE THINGS IN THE SKY? THOSE...PATTERNS?

AH, THOSE ARE MY OLD NORTHERN LIGHTS. SEE HOW THEY FLASH? IT MEANS WE'RE GETTING FURTHER NORTH.

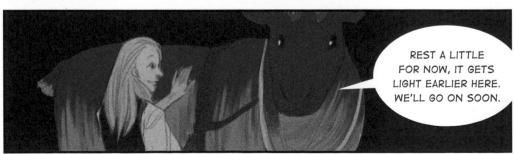

REST A LITTLE FOR NOW, IT GETS LIGHT EARLIER HERE. WE'LL GO ON SOON.

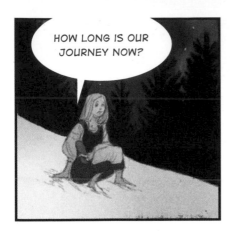

HOW LONG IS OUR JOURNEY NOW?

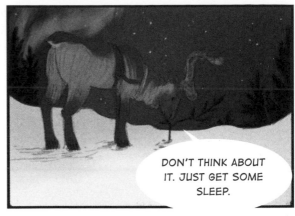

DON'T THINK ABOUT IT. JUST GET SOME SLEEP.

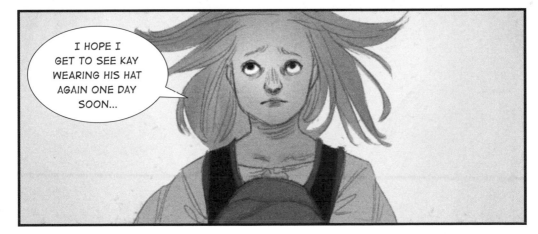

I HOPE I GET TO SEE KAY WEARING HIS HAT AGAIN ONE DAY SOON...

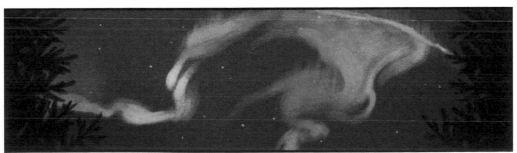

CHAPTER
~SIX~

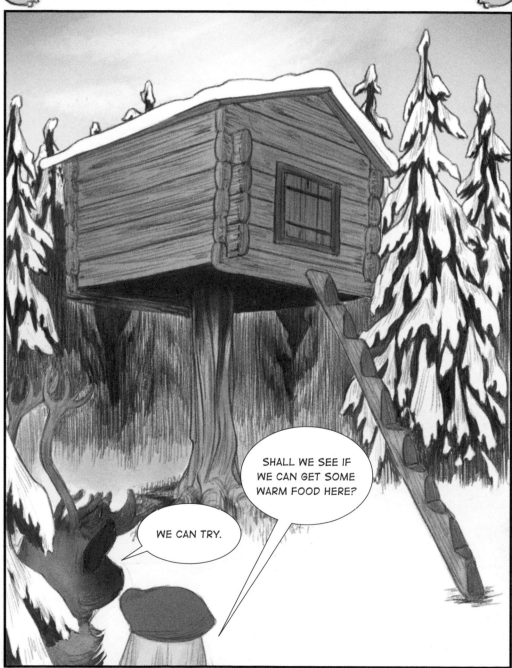

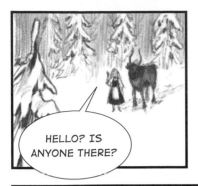

HELLO? IS ANYONE THERE?

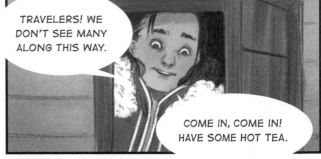

TRAVELERS! WE DON'T SEE MANY ALONG THIS WAY.

COME IN, COME IN! HAVE SOME HOT TEA.

SOME TIME LATER...

WHAT AN EXTRAORDINARY TALE! THE WORST OF IT IS THAT YOU STILL HAVE ANOTHER HUNDRED OR SO MILES TO GO.

THE LAND OF THE SNOW QUEEN IS FURTHER TO THE SOUTH OF FINLAND.

IF YOU GO AS FAR AS THE FINNISH WOMAN'S HOUSE, SHE COULD GIVE YOU BETTER DIRECTIONS. SHE'S WISE, TOO.

HOW DO WE FIND HER?

I'LL GIVE YOU A FEW INSTRUCTIONS HERE ON THIS PIECE OF DRIED FISH.

NOW YOU'LL BE SURE TO FIND HER.

THANK YOU, WE SHOULD HEAD STRAIGHT THERE.

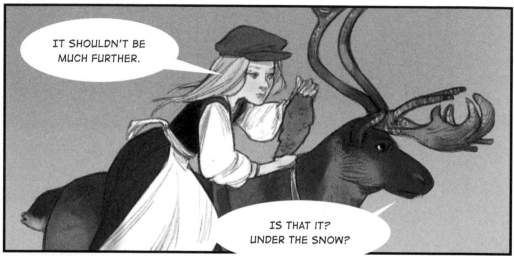

IT SHOULDN'T BE MUCH FURTHER.

IS THAT IT? UNDER THE SNOW?

IT LOOKS LIKE SHE WAS EXPECTING US.

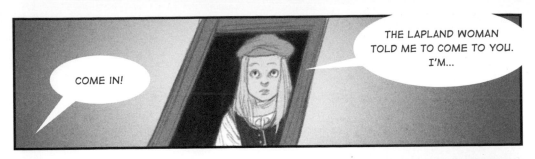

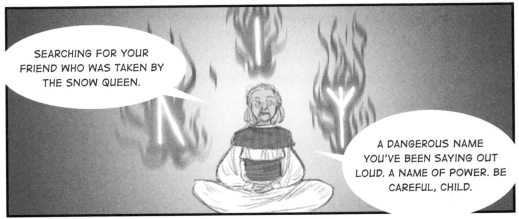

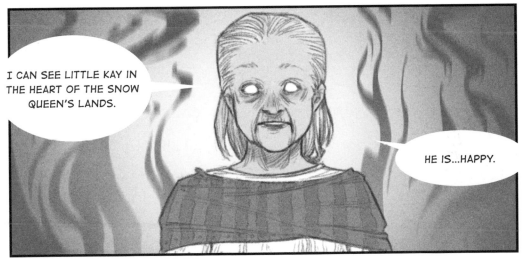

HE WAS ALREADY COLD BEFORE THE SNOW QUEEN TOOK HIM.

HE HAS A SHARD OF BROKEN GLASS IN HIS HEART, ANOTHER IN HIS EYE. UNTIL THEY ARE TAKEN OUT, THEY WILL STILL HAVE POWER OVER HIM.

THAT WOULD EXPLAIN WHY HE WAS SO HURTFUL BEFORE.

HOW DO I TAKE THE SHARDS OUT?

I CAN'T SEE...YOU MIGHT NEED TO FIND THAT OUT FOR YOURSELF.

I KNOW YOU HAVE GREAT MAGIC. CAN YOU NOT GIVE THE GIRL SOMETHING TO HELP HER FIGHT? TO KEEP HER SAFE?

CAN'T YOU SEE HOW STRONG SHE ALREADY IS? SHE HAS A BRAVE, PURE HEART.

I CANNOT GIVE HER ANYTHING SHE DOESN'T ALREADY HAVE.

PAST THE TOP OF THAT PEAK IS THE BORDER TO THE LAND OF THE SNOW QUEEN. YOU MUST LEAVE GERDA THERE.

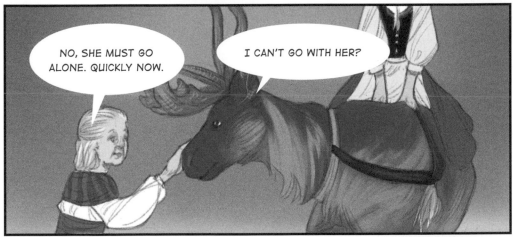

NO, SHE MUST GO ALONE. QUICKLY NOW.

I CAN'T GO WITH HER?

CHAPTER
~ SEVEN ~

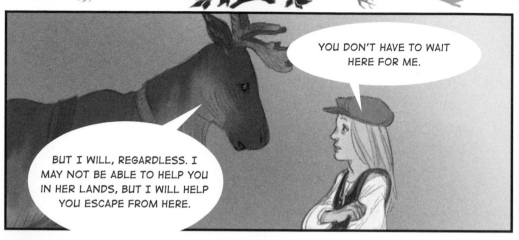

YOU DON'T HAVE TO WAIT HERE FOR ME.

BUT I WILL, REGARDLESS. I MAY NOT BE ABLE TO HELP YOU IN HER LANDS, BUT I WILL HELP YOU ESCAPE FROM HERE.

THANK YOU, MY FRIEND.

WELL, HERE GOES...

HUH?

OH NO!

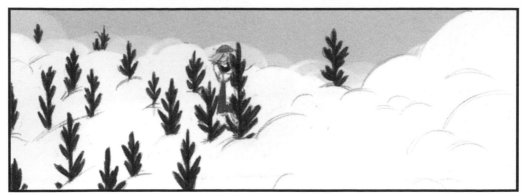

TOO CLOSE...

HUH?
IS THAT...

A VOLCANO?!

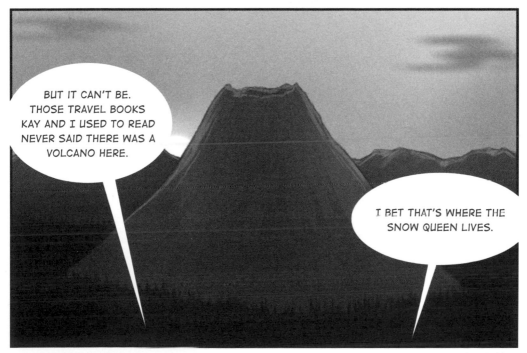

BUT IT CAN'T BE. THOSE TRAVEL BOOKS KAY AND I USED TO READ NEVER SAID THERE WAS A VOLCANO HERE.

I BET THAT'S WHERE THE SNOW QUEEN LIVES.

NOW, HOW DO I GET THERE?

MOREOVER, HOW DO I GET THERE WHEN I CAN'T SEE?

IS THIS JUST LEFT OVER FROM THE AVALANCHE?

IT FEELS SO STRONG. A BLIZZARD?

THIS CAN'T JUST BE BAD LUCK. SHE'S TRYING TO STOP ME FROM GETTING TO KAY.

NO. IT'S NOT GOING TO WORK.

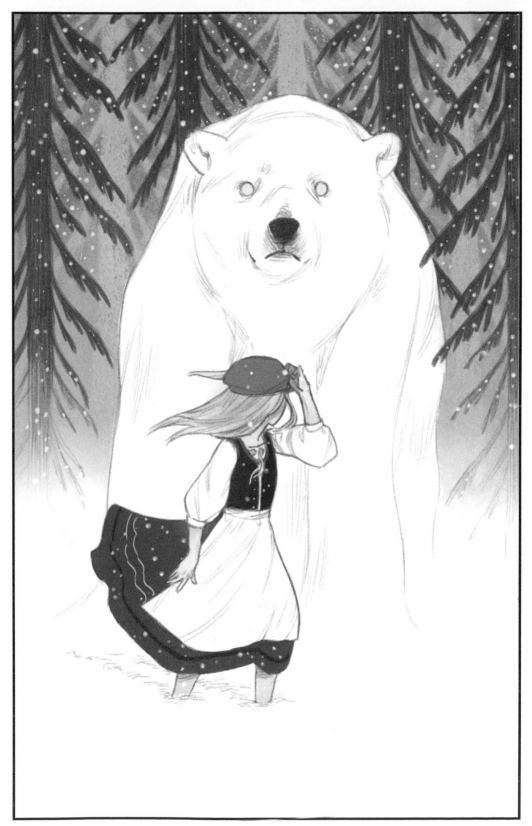

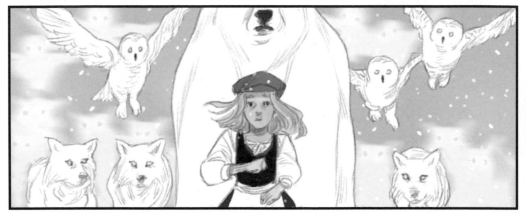

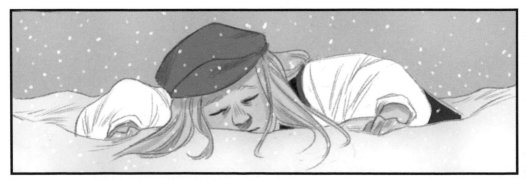

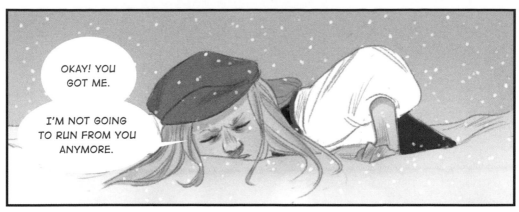

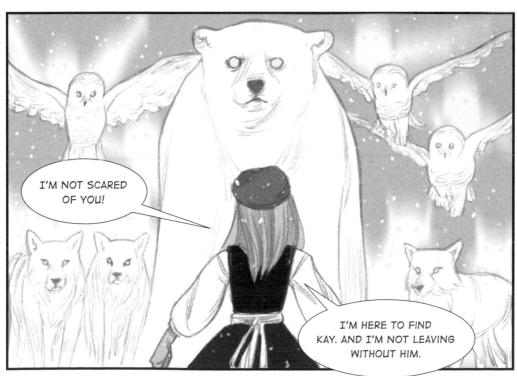

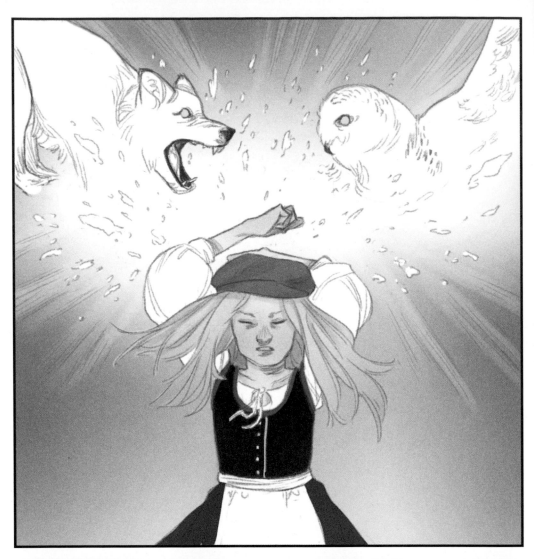

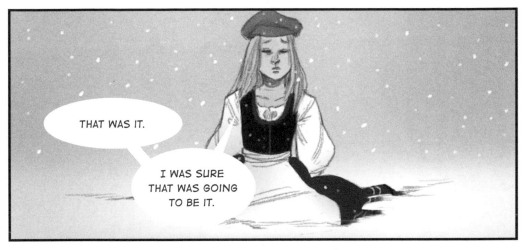

THAT WAS IT.

I WAS SURE THAT WAS GOING TO BE IT.

I WAS RIGHT BEFORE. SHE'S TRYING TO DRIVE ME AWAY.

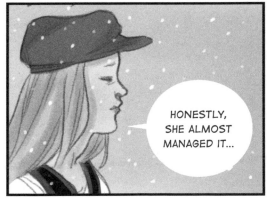

HONESTLY, SHE ALMOST MANAGED IT...

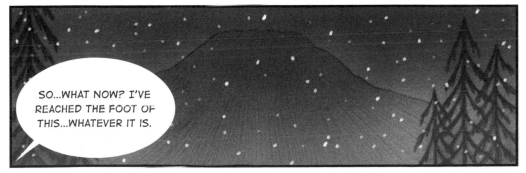

SO...WHAT NOW? I'VE REACHED THE FOOT OF THIS...WHATEVER IT IS.

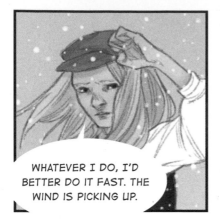

THE SNOWFLAKES REALLY DO FEEL LIKE BEES.

WHATEVER I DO, I'D BETTER DO IT FAST. THE WIND IS PICKING UP.

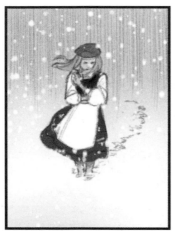

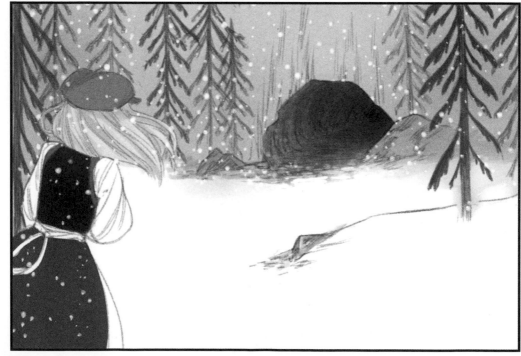

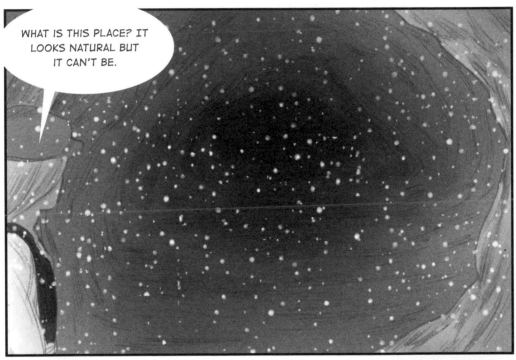
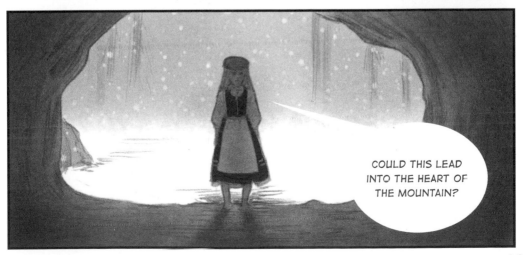

THAT WAS CLOSE!

I GUESS I SHOULD TAKE IT SLOW FROM HERE ON...

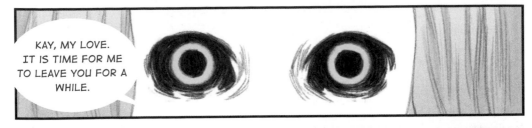

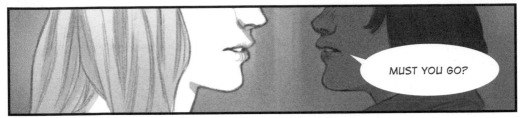

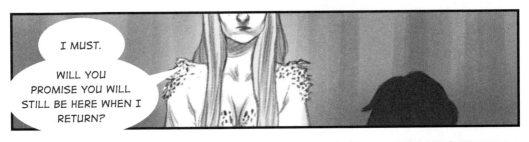

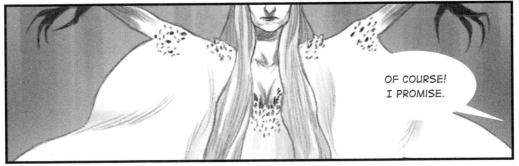

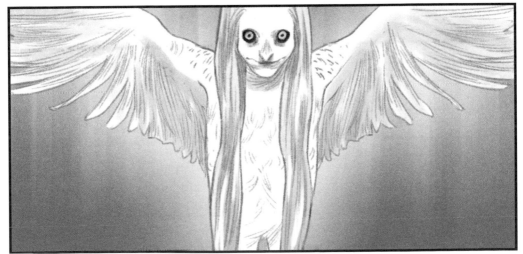

HUH? SOMEONE'S COMING!

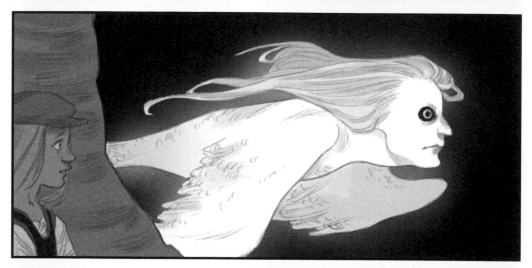

THAT WAS HER! THE SNOW QUEEN!

I DIDN'T THINK IT COULD GET ANY COLDER...

...AND...LOUDER? WHAT'S RUMBLING?

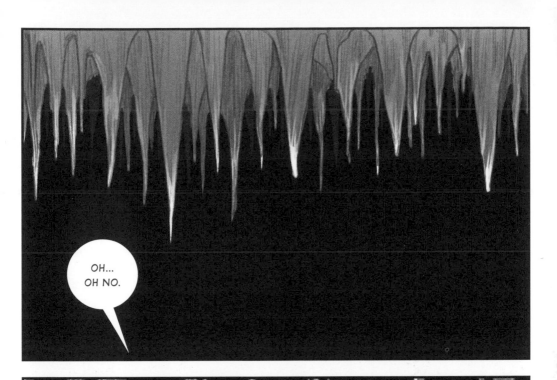

OH...
OH NO.

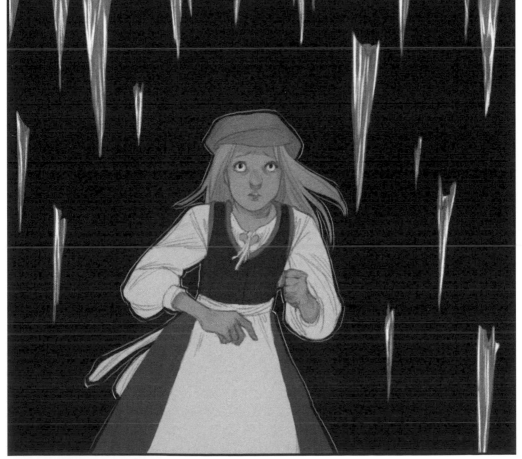

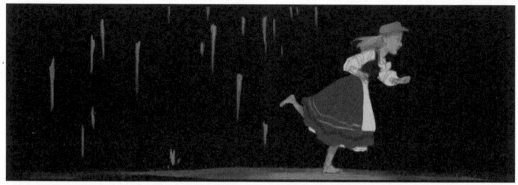
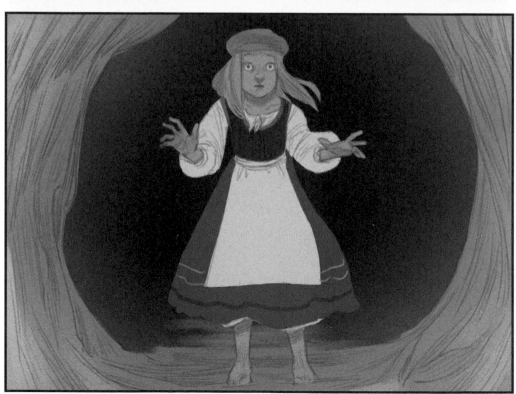

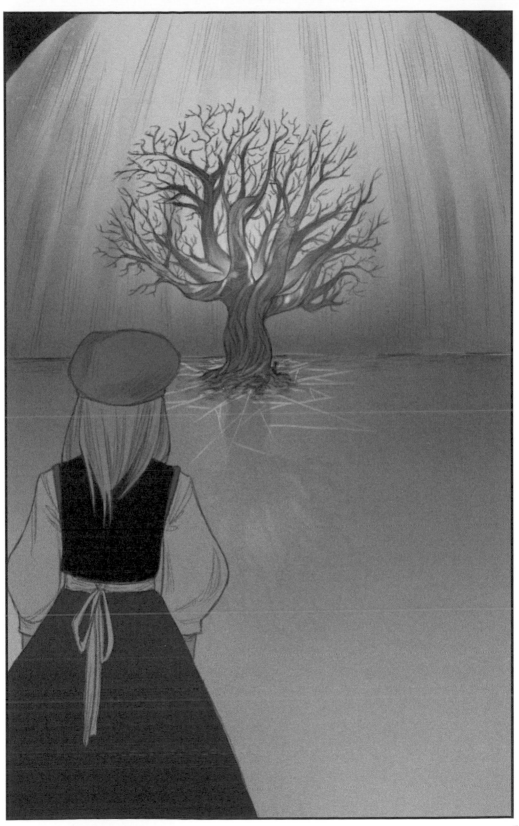

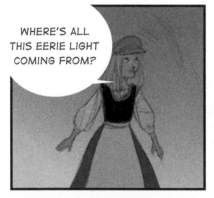

WHERE'S ALL THIS EERIE LIGHT COMING FROM?

OH—THE NORTHERN LIGHTS! OF COURSE!

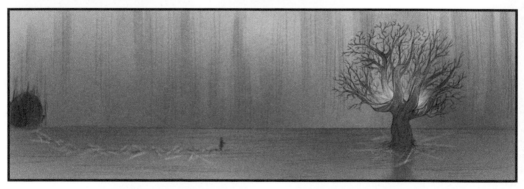

NOT FAR NOW. WAIT, IS THAT...KAY?

KAY! IS THAT YOU?

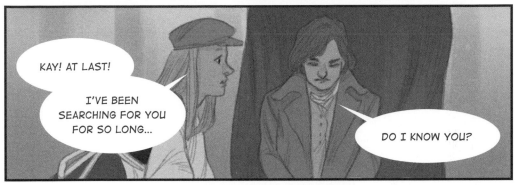

KAY! AT LAST!

I'VE BEEN SEARCHING FOR YOU FOR SO LONG...

DO I KNOW YOU?

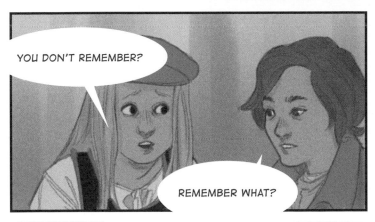

YOU DON'T REMEMBER?

REMEMBER WHAT?

THE TOWN, AND OUR ROOFTOP GARRETS...AND OUR GARDEN WITH OUR RED ROSES...

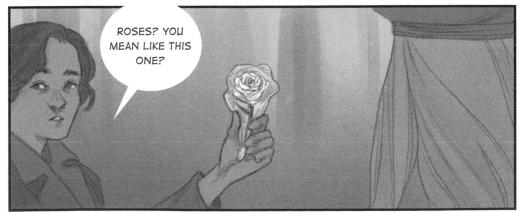

ROSES? YOU MEAN LIKE THIS ONE?

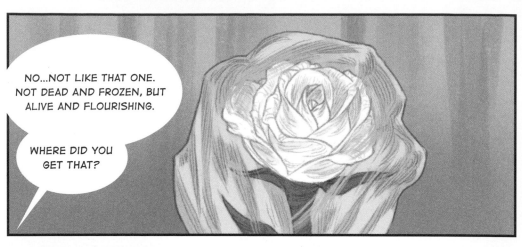

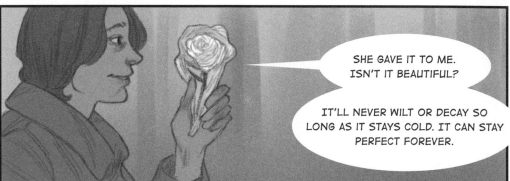

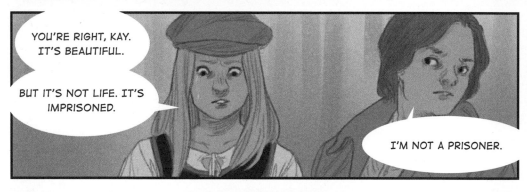

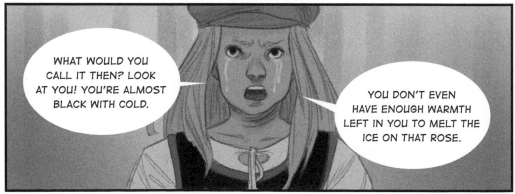

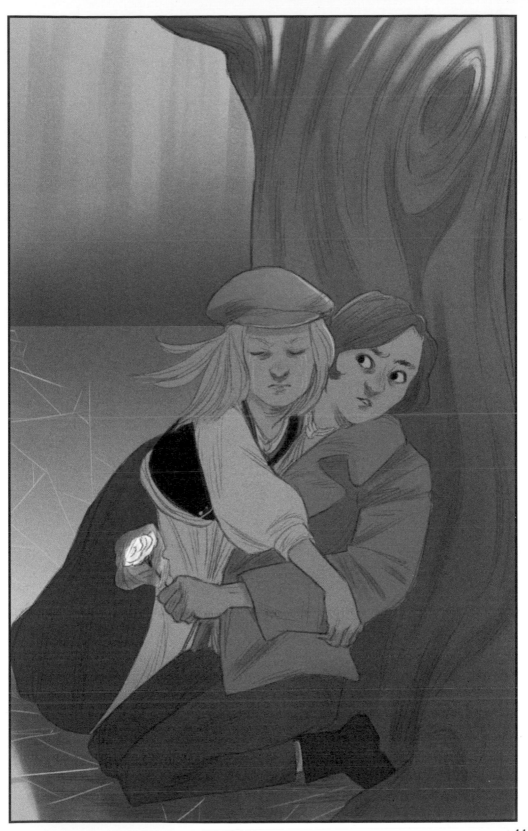

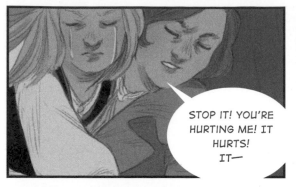
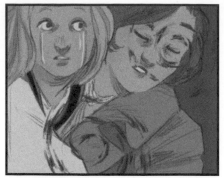

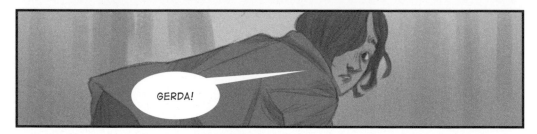
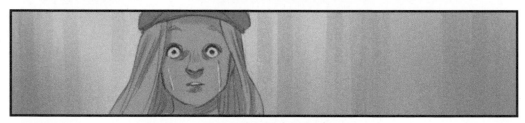
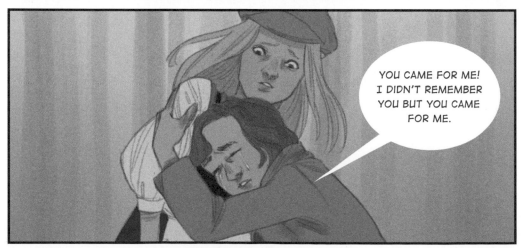

116

MY HAT!

YOU LOST IT, CARELESS.

I CAN'T BELIEVE YOU CAME. AFTER I HURT YOU... EVEN AFTER THAT...

IT WASN'T YOU. I KNEW IT WASN'T.

OH—YOUR ROSE!

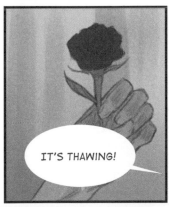

IT'S THAWING!

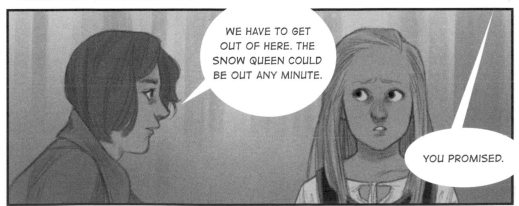

WE HAVE TO GET OUT OF HERE. THE SNOW QUEEN COULD BE OUT ANY MINUTE.

YOU PROMISED.

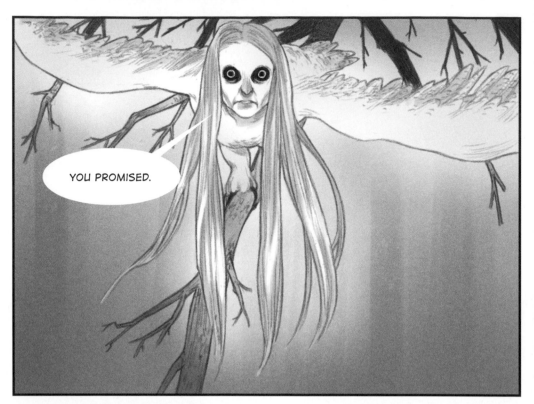

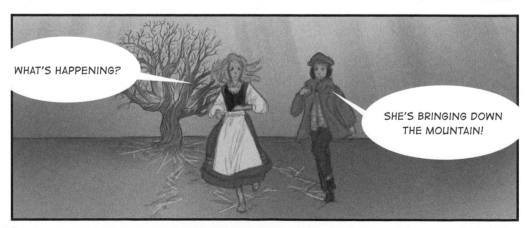

GERDA!

ARE YOU OK?

I'M FINE. HURRY!

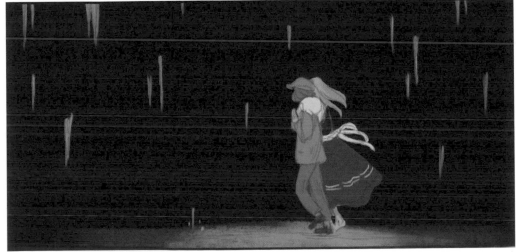

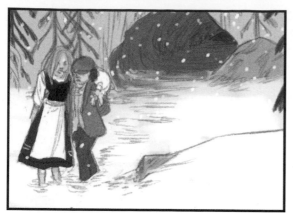

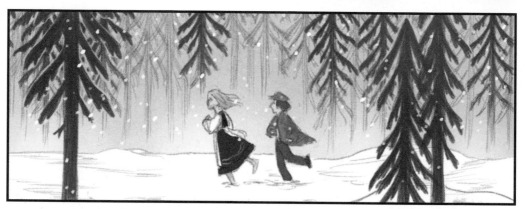
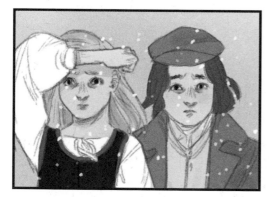

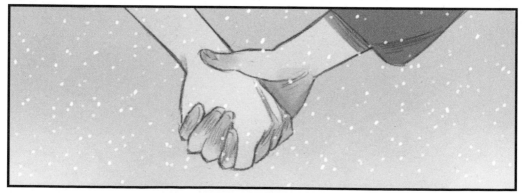

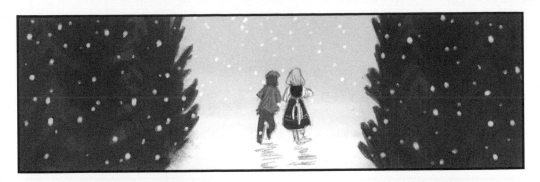

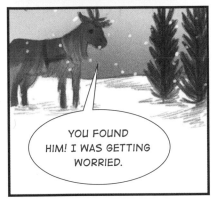

YOU FOUND HIM! I WAS GETTING WORRIED.

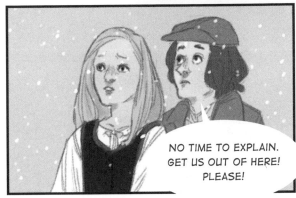

NO TIME TO EXPLAIN. GET US OUT OF HERE! PLEASE!

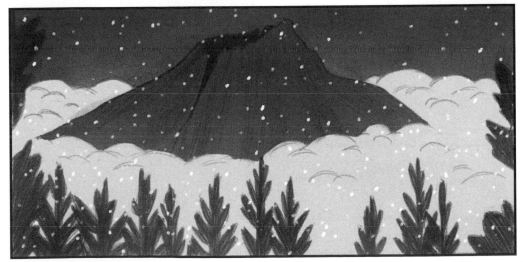

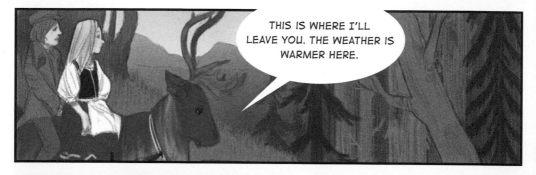

THIS IS WHERE I'LL LEAVE YOU. THE WEATHER IS WARMER HERE.

GOODBYE, FRIEND! AND THANK YOU!

IT'S OK. HE'LL BE FREE NOW.

IT'S NOT THAT. I HAD ANOTHER FRIEND I WISH I COULD SEE AGAIN. HE HELPED ME SO MUCH.

CAW! YOU DID IT!

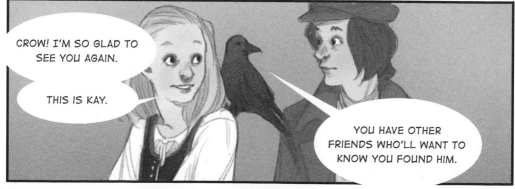

CROW! I'M SO GLAD TO SEE YOU AGAIN.

THIS IS KAY.

YOU HAVE OTHER FRIENDS WHO'LL WANT TO KNOW YOU FOUND HIM.

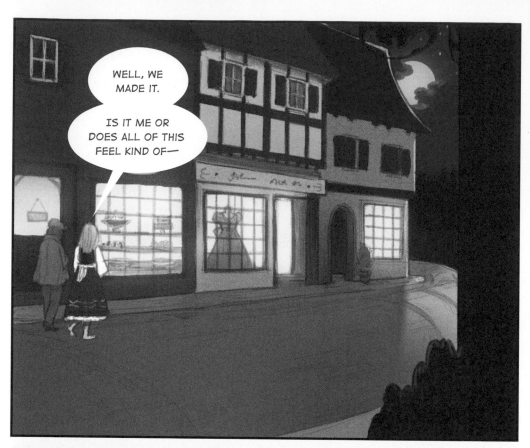

124

COME OVER FOR DINNER LATER?

AND THE WHOLE MOUNTAIN STARTED RUMBLING!

LIKE IT WAS GOING TO EXPLODE!

AND THE FROZEN LAKE STARTED TO CRACK!

AND I FELL THROUGH THE ICE, BUT KAY SAVED ME.

BUT IF IT WEREN'T FOR GERDA I'D STILL BE THERE.

YOU TWO REALLY HAVE HAD QUITE AN ADVENTURE. AND BOTH SO BRAVE—

OH MY! THE FIRST WINTER SNOW.

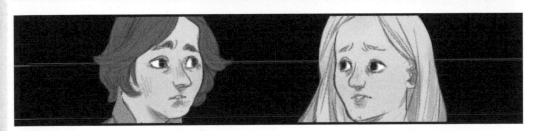

ACKNOWLEDGMENTS

With immense gratitude to my mother for her tireless support and encouragement, to Marcus for his inexhaustible care and patience, and to my friends for their honest and valuable critique. Lastly, to the kitten who warmed my lap as I drew through the winter months.